Carrie Hitchens
Color Me Chemistry
80 pages of sciency, molecular coloring fun for adults

Color me Chemistry is a collection of molecules to color. Each molecule has fun geometric patterns and angles to make each molecule beautiful. If you enjoy chemistry, science, or just good detailed coloring books, then this book is for you.

So sit down with some molecules and color your stress away.

All images and materials obtained in this book are the propery of Carrie A Hitchens and are copyrighted on September 27, 2016. No unauthorized copying or use of images allowed.

Copyright 2016 by Carrie Hitchens. All rights reserved.

Bibiographical note

Color Me Chemistry 80 pages of sciency, molecular coloring fun for adults is a new work, first published by Carrie A. Hitchens in 2016

Manufactured in the United States by CreateSpace Publishing

International Standard Book Number

ISBN-13:
978-1539096177

ISBN-10:
1539096173

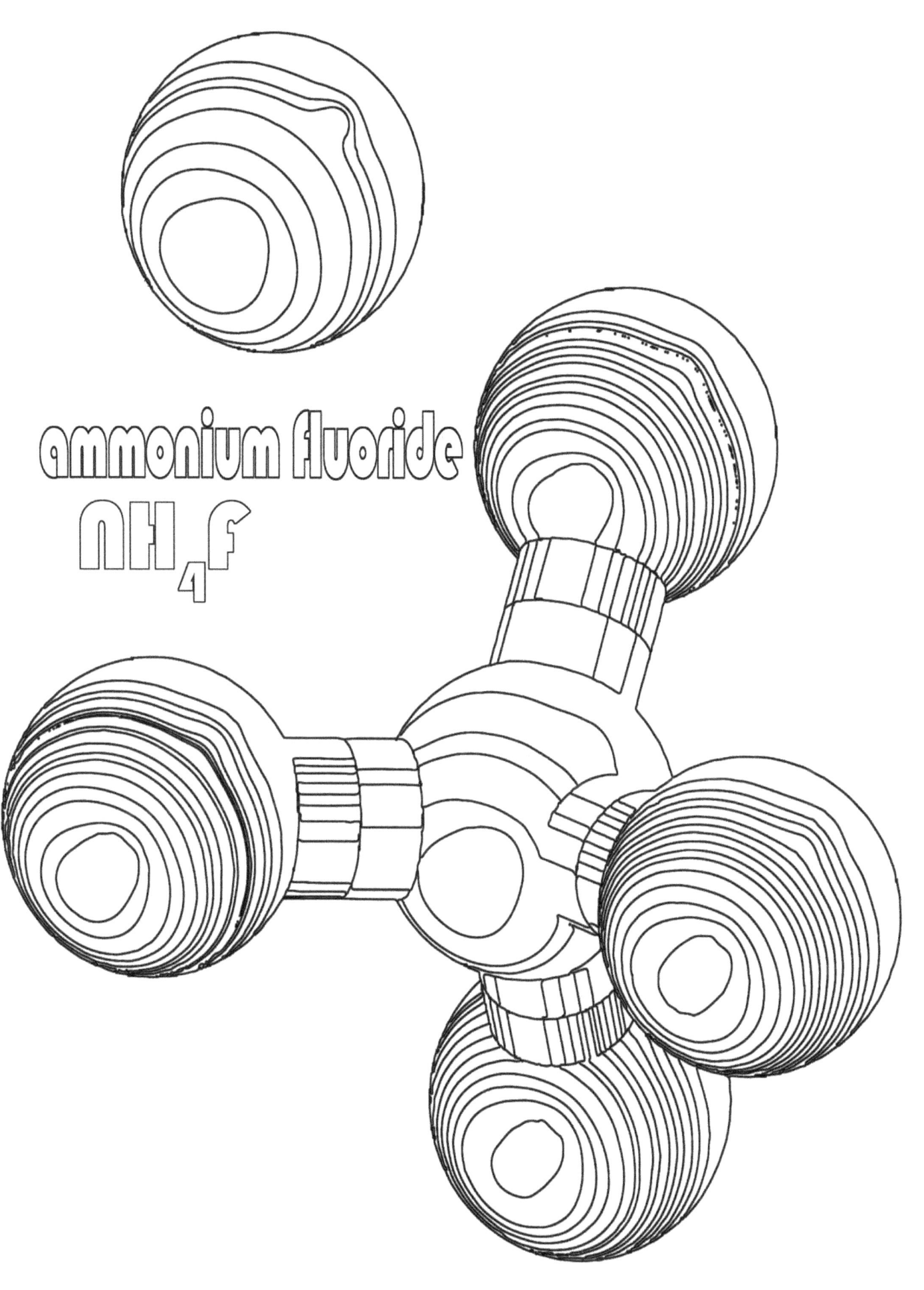

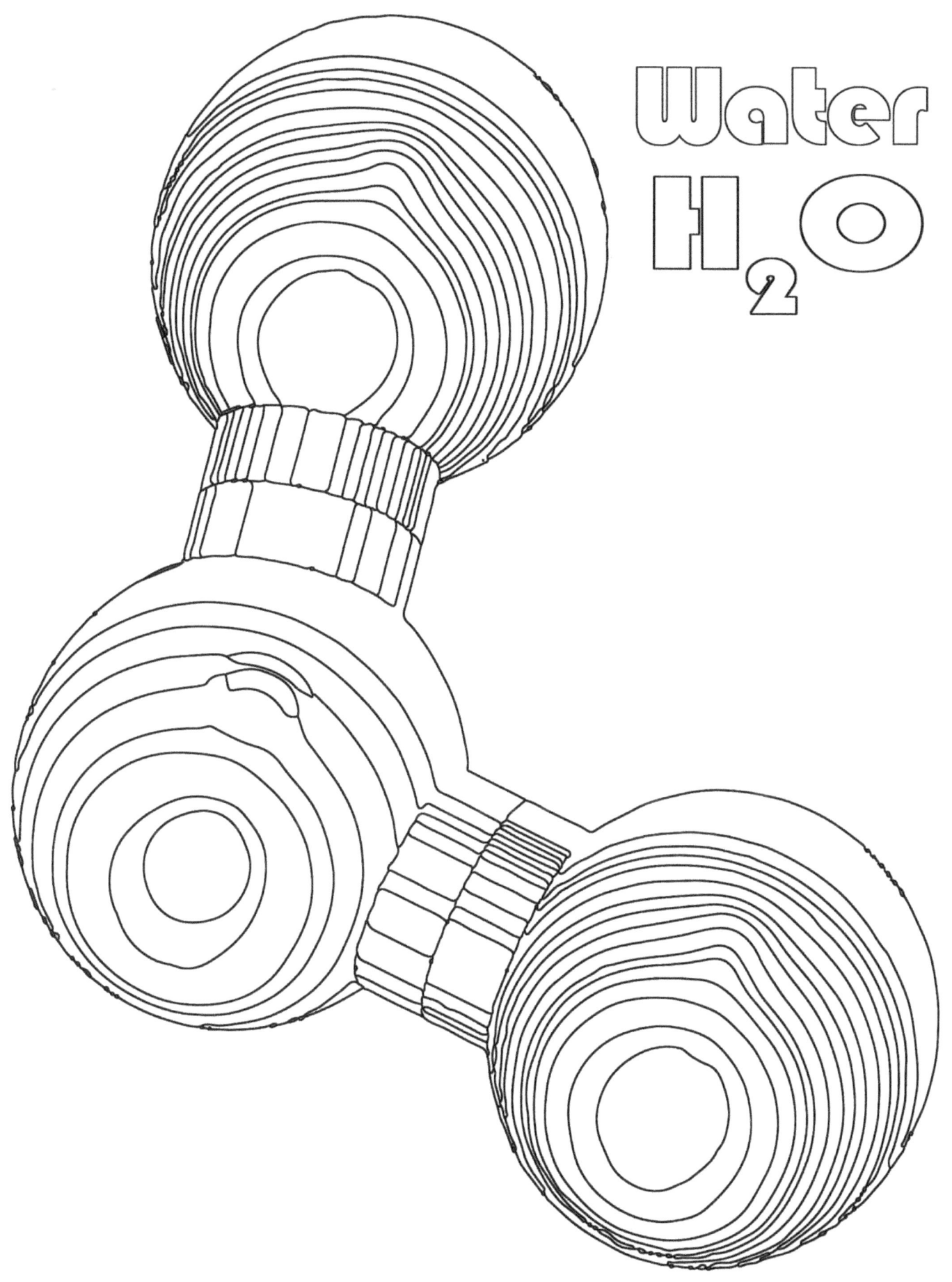

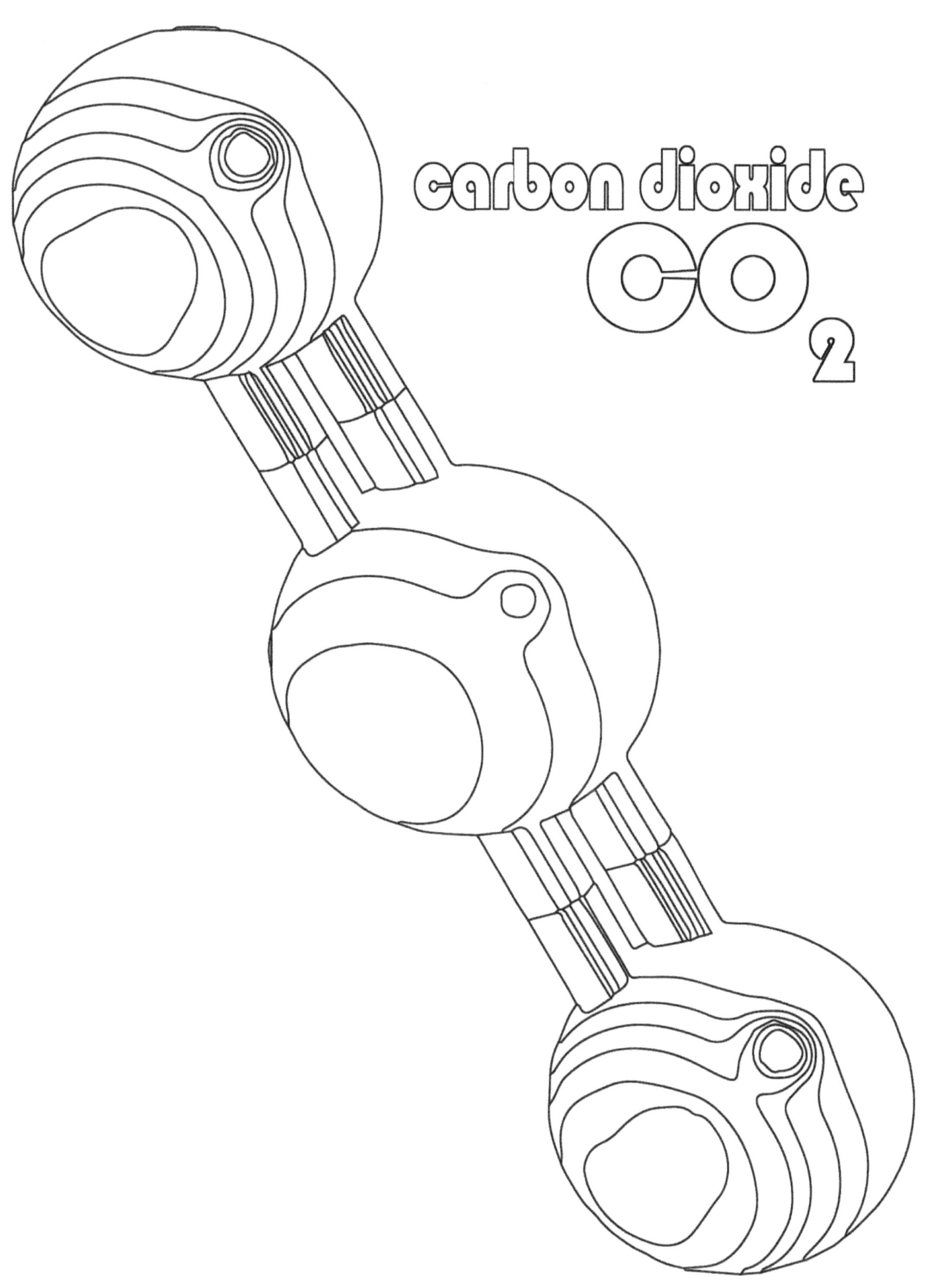

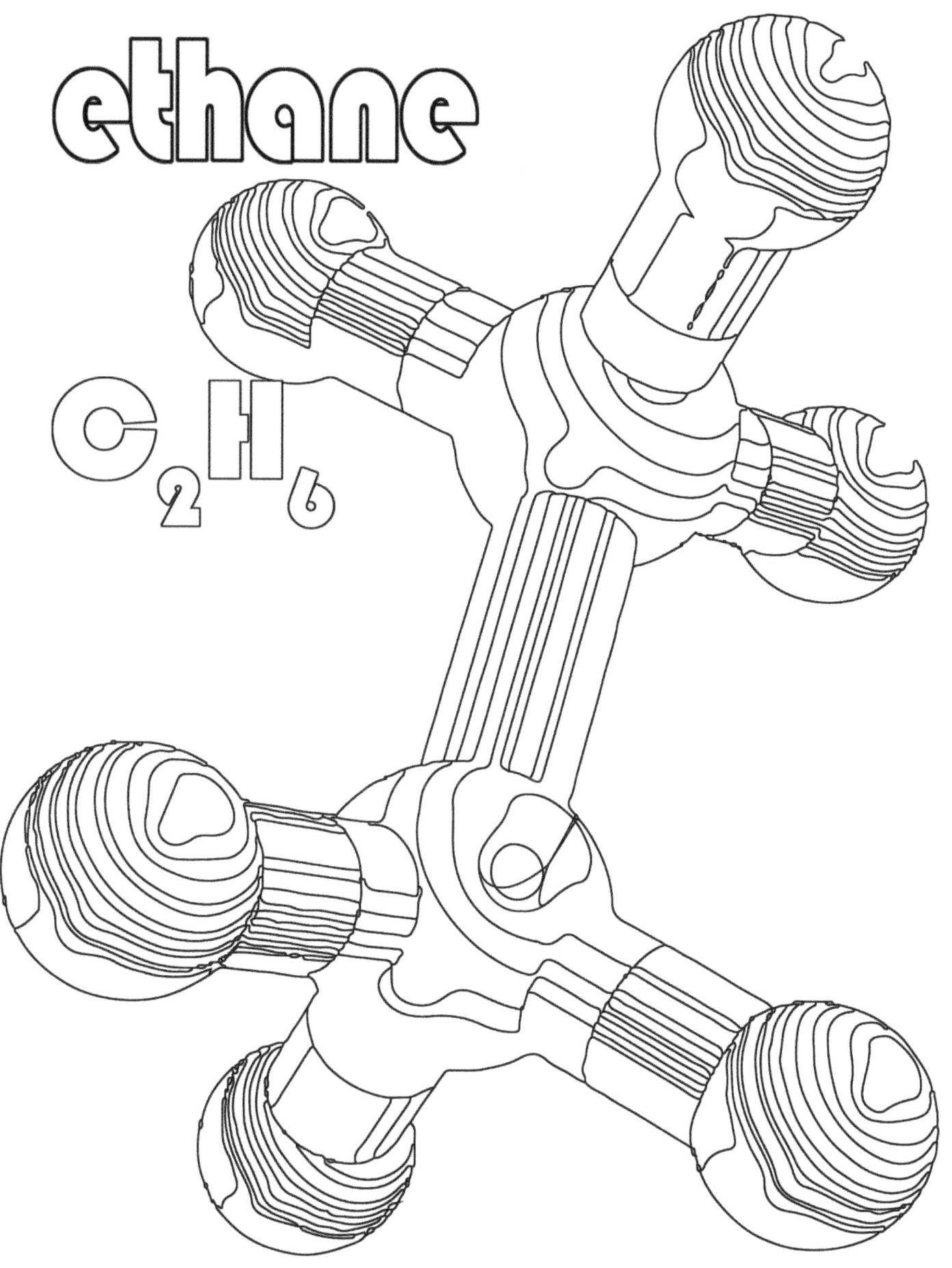

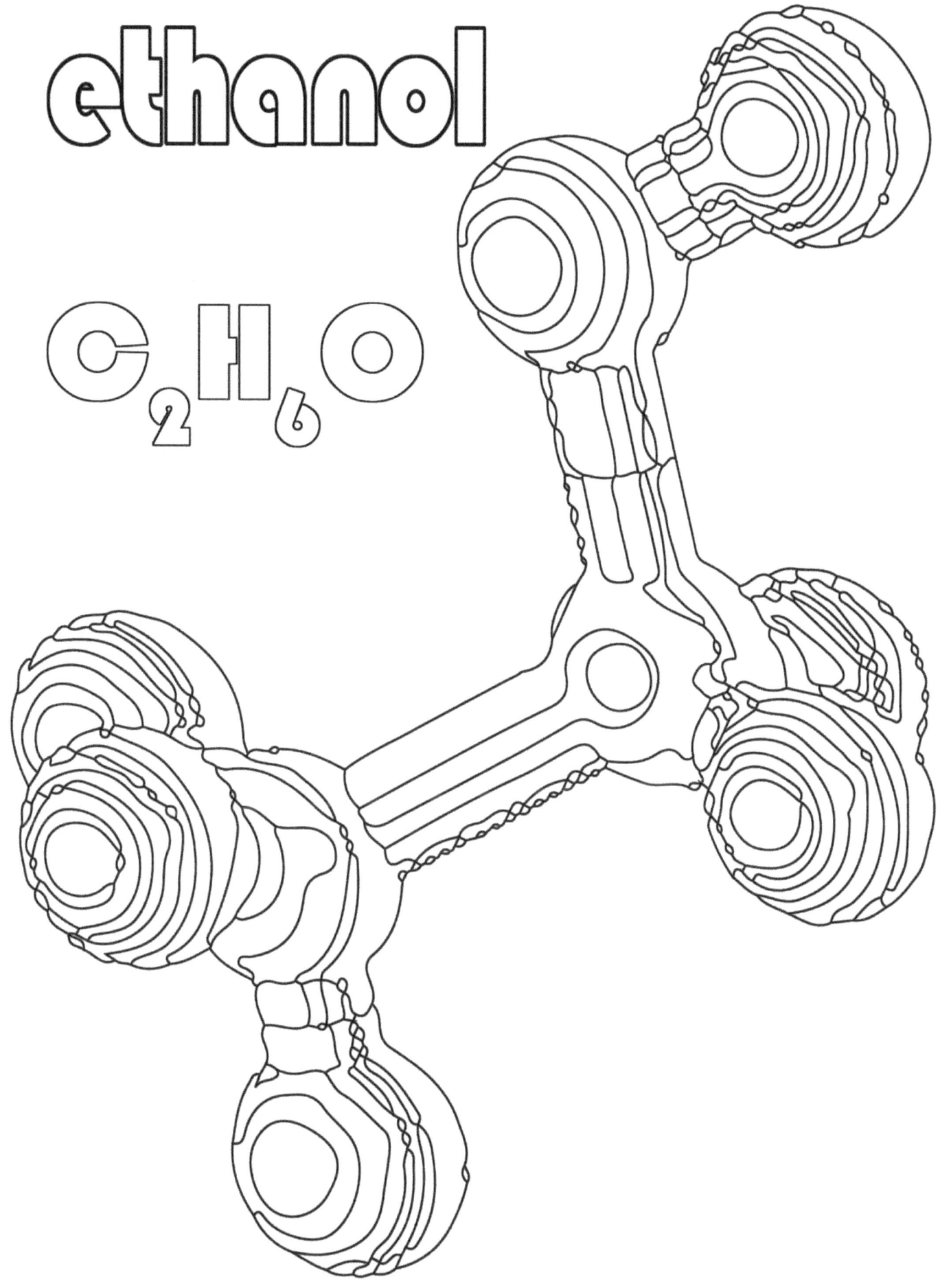

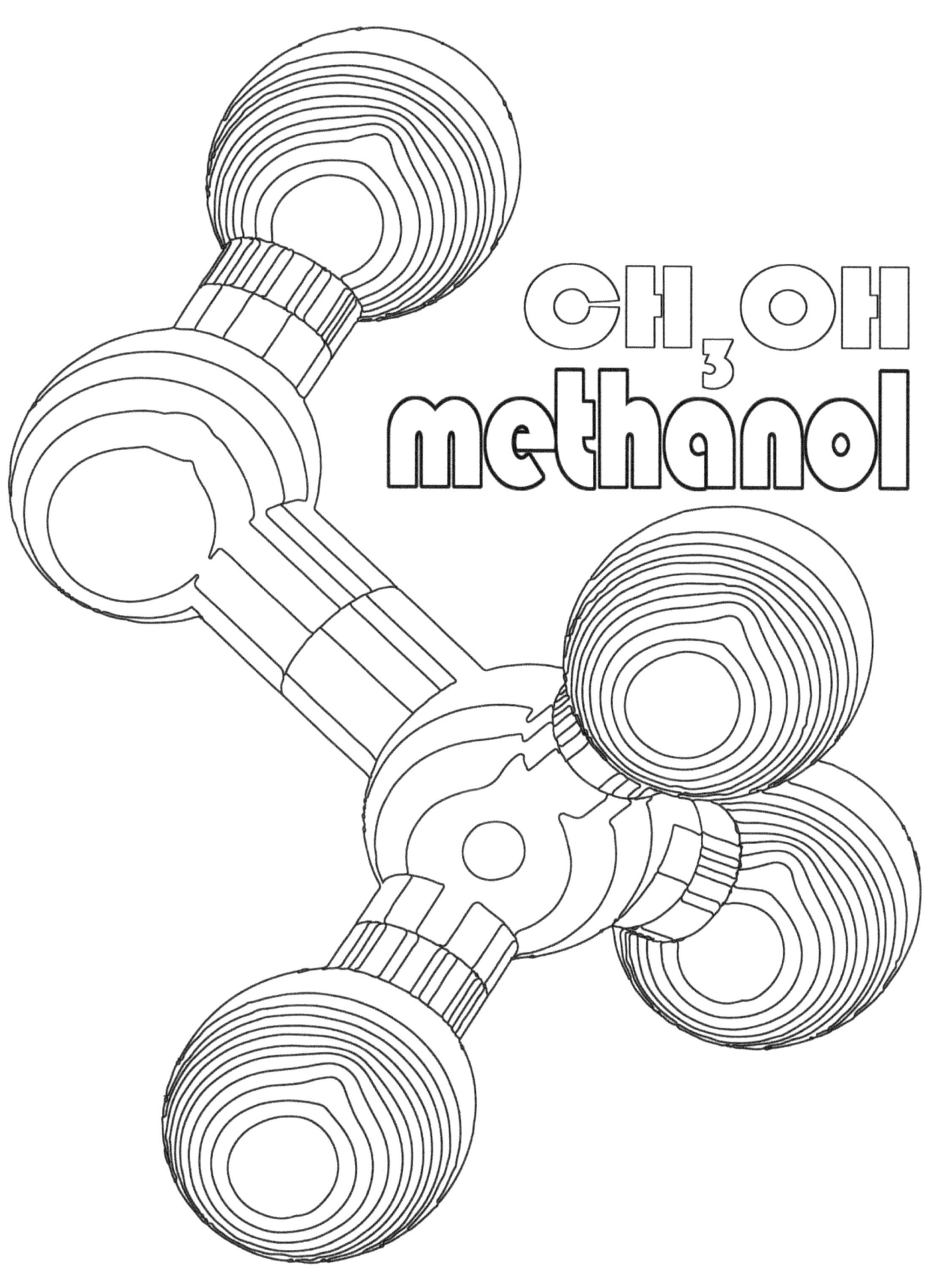

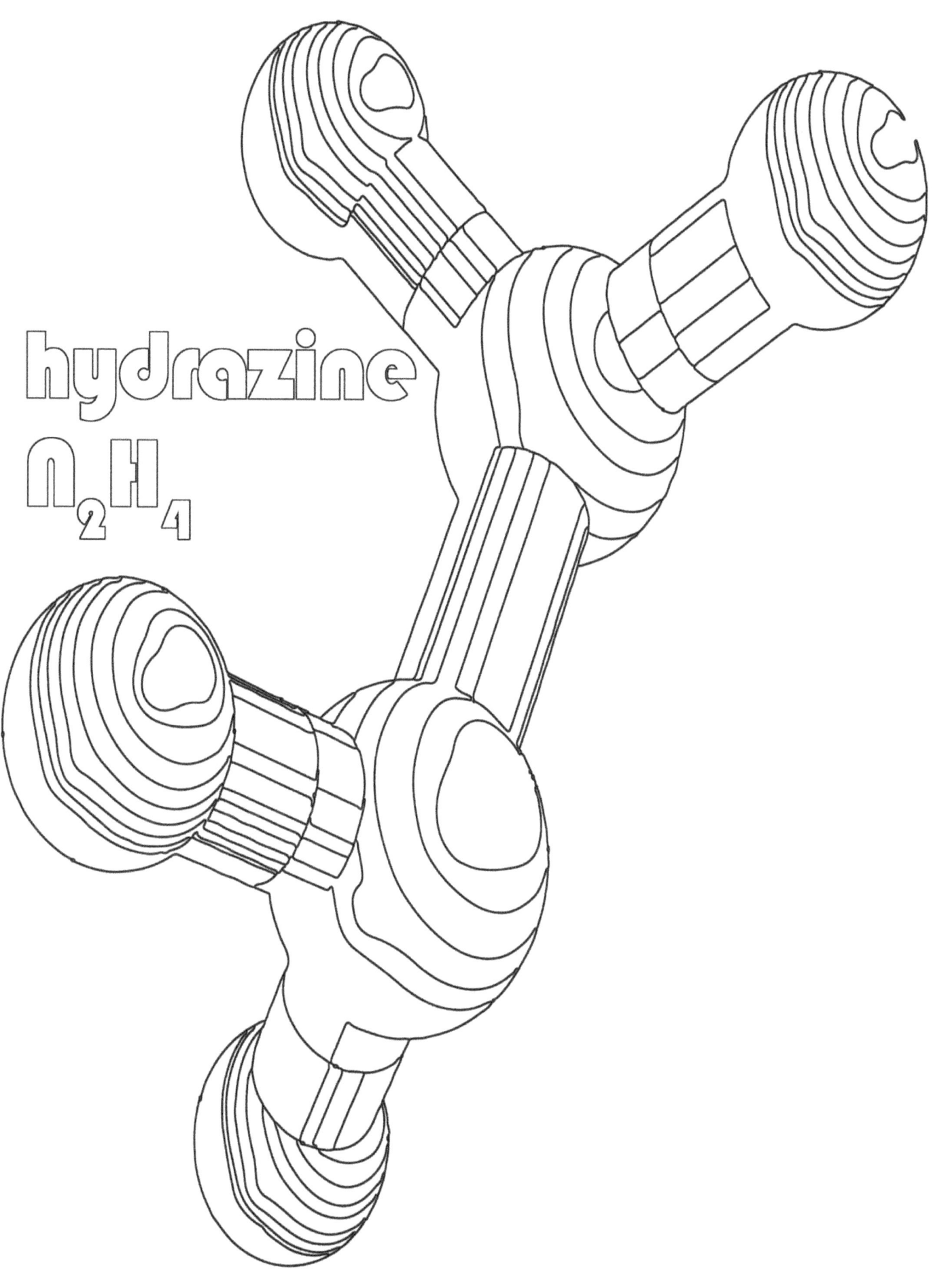

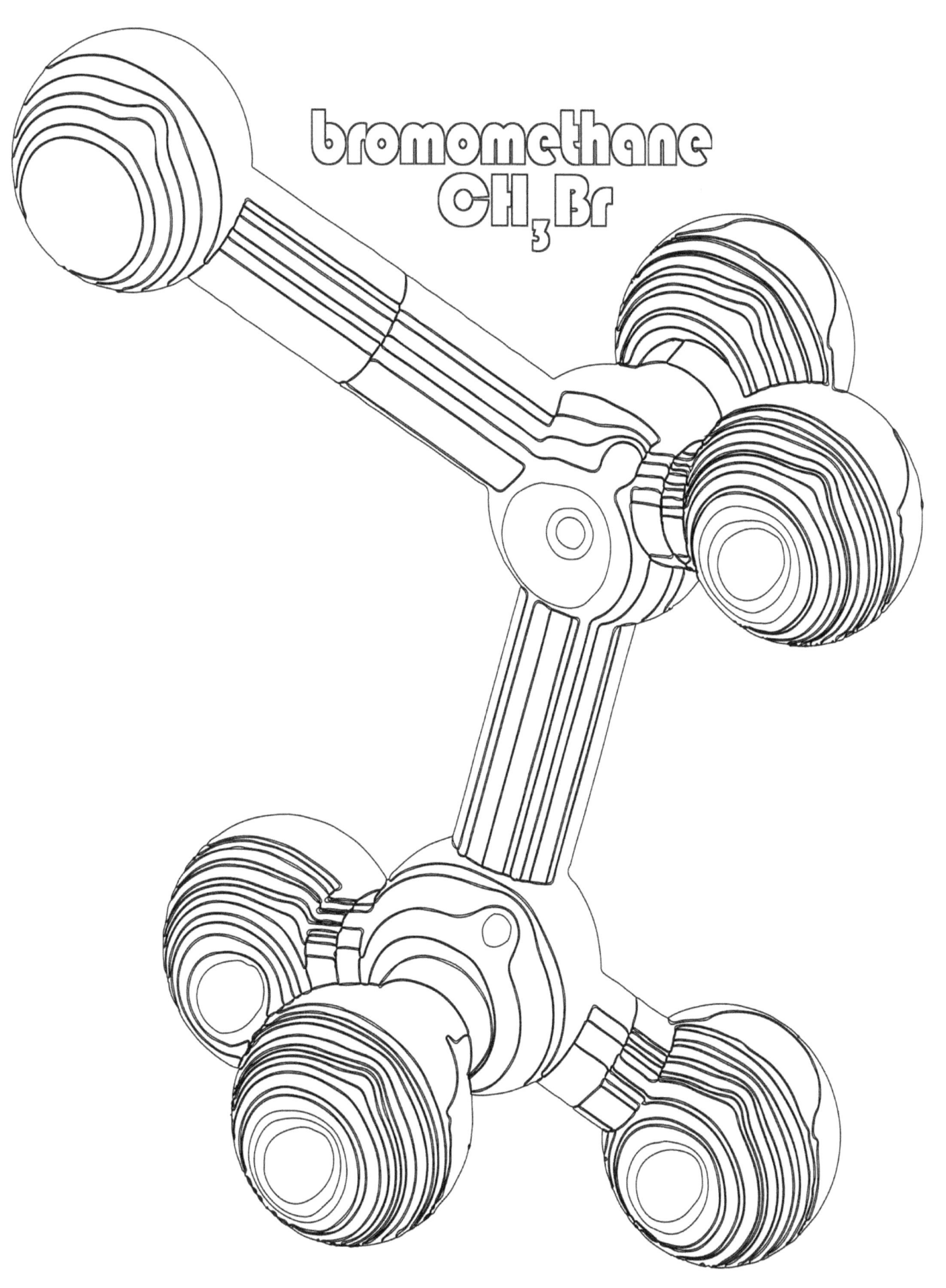

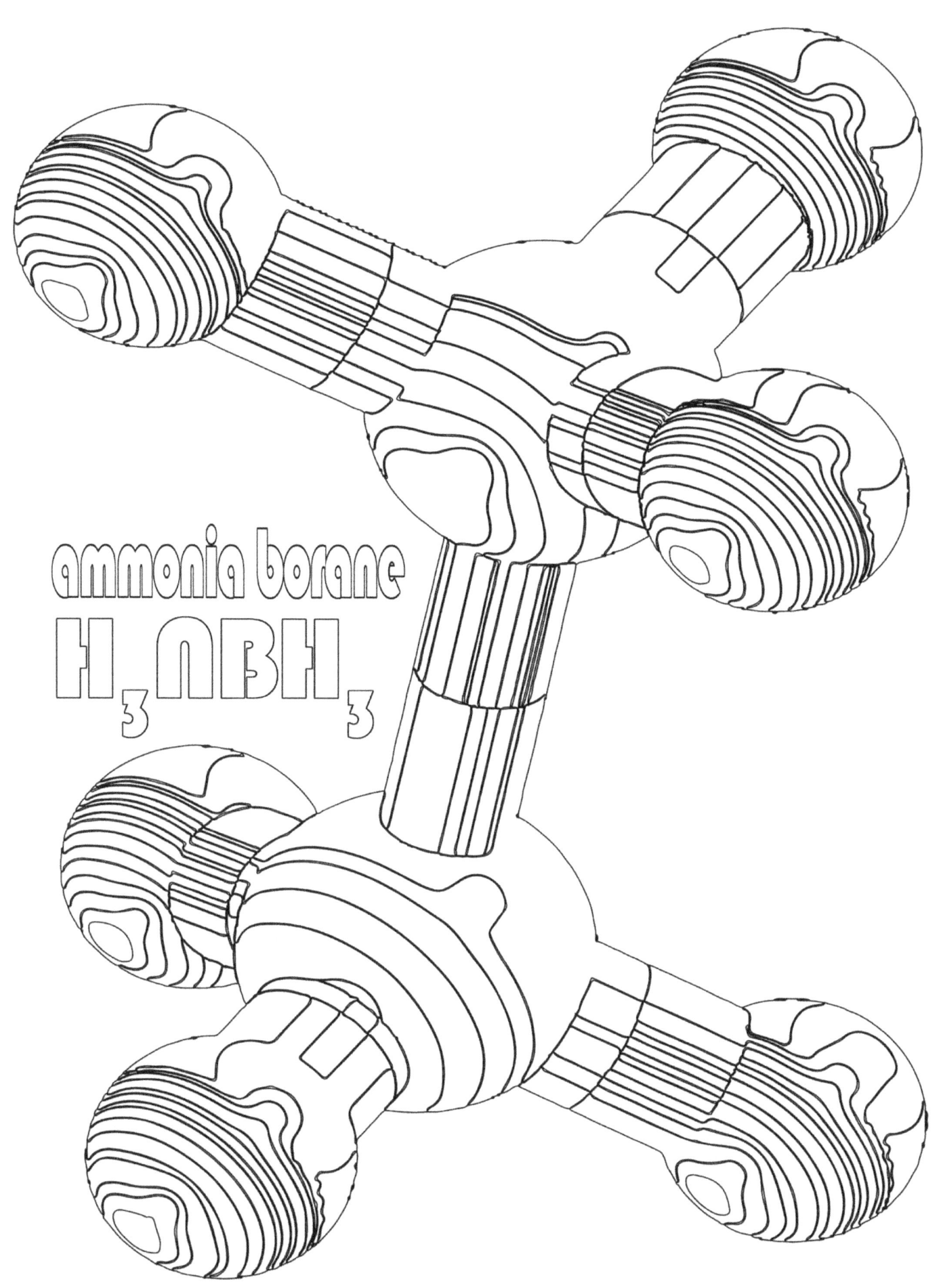

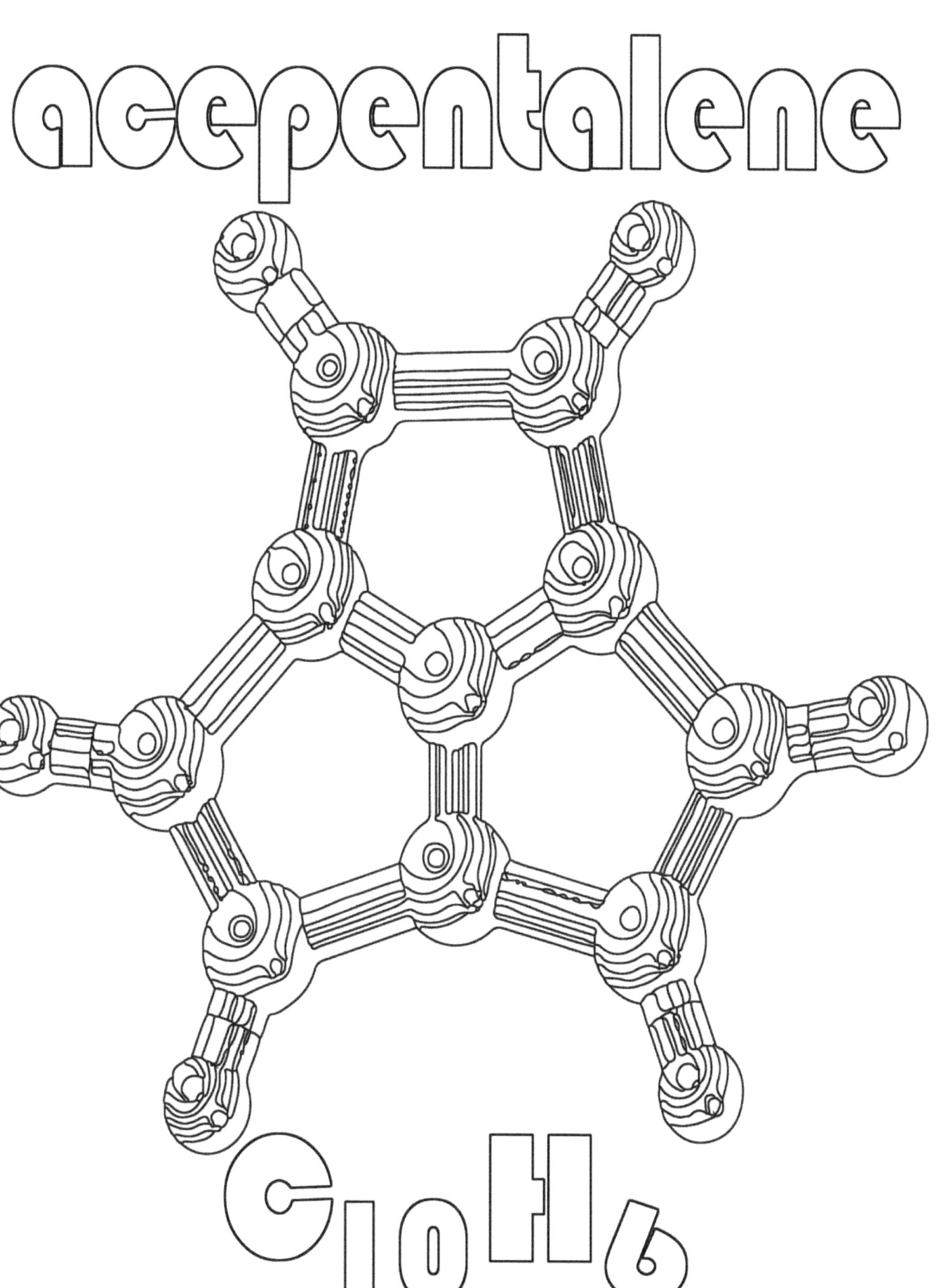

acetaldehyde

C_2H_4O

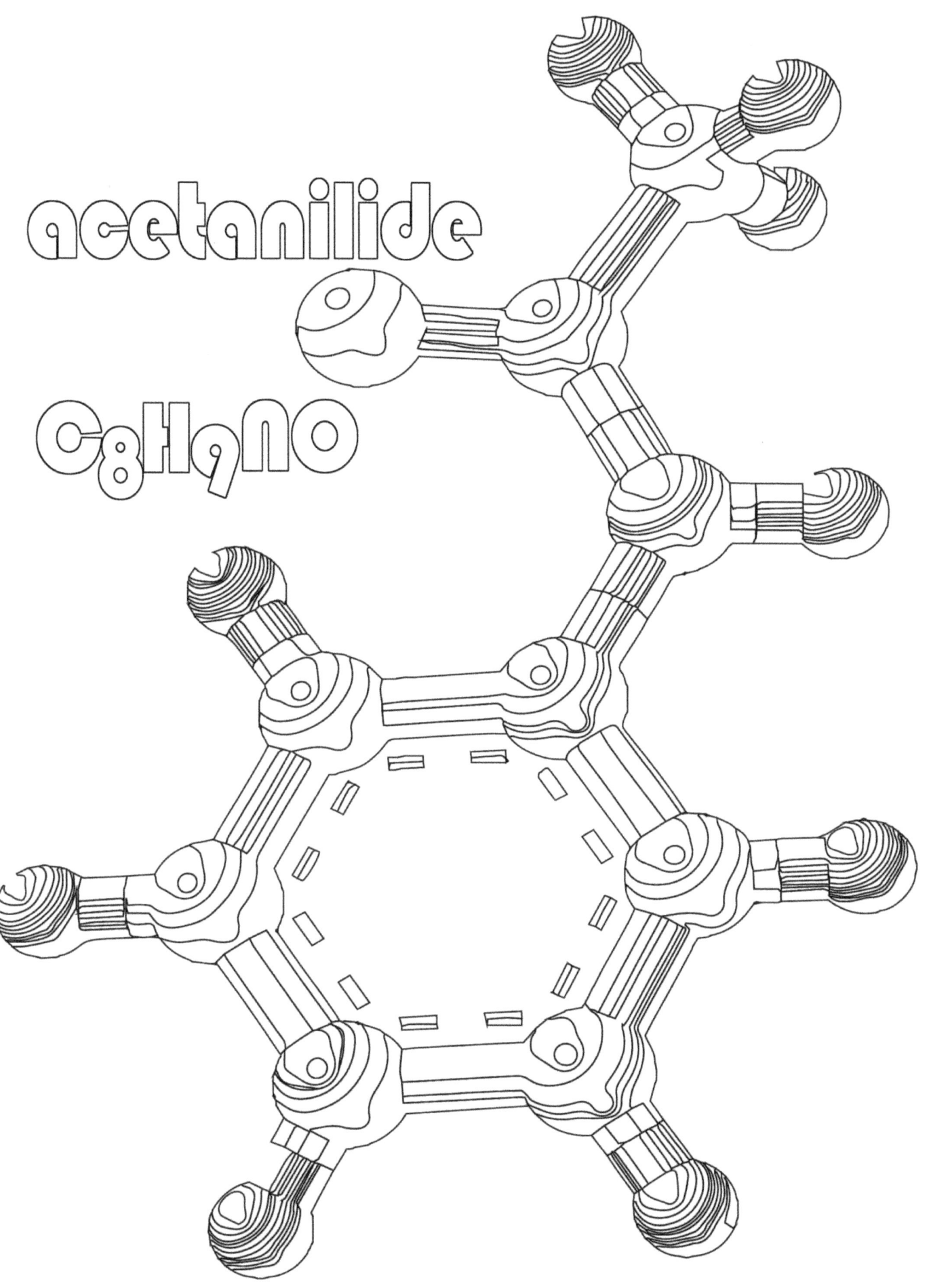

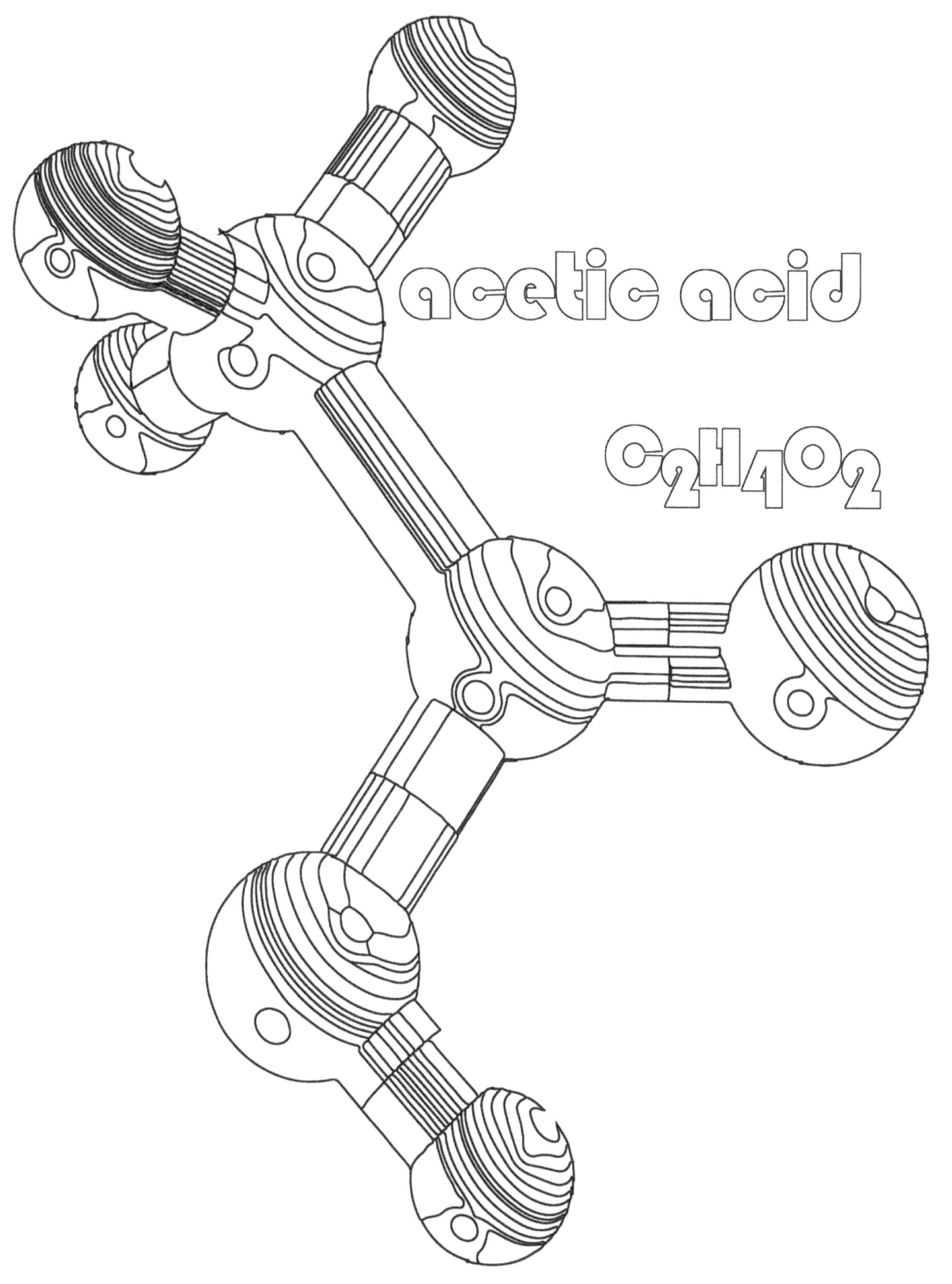

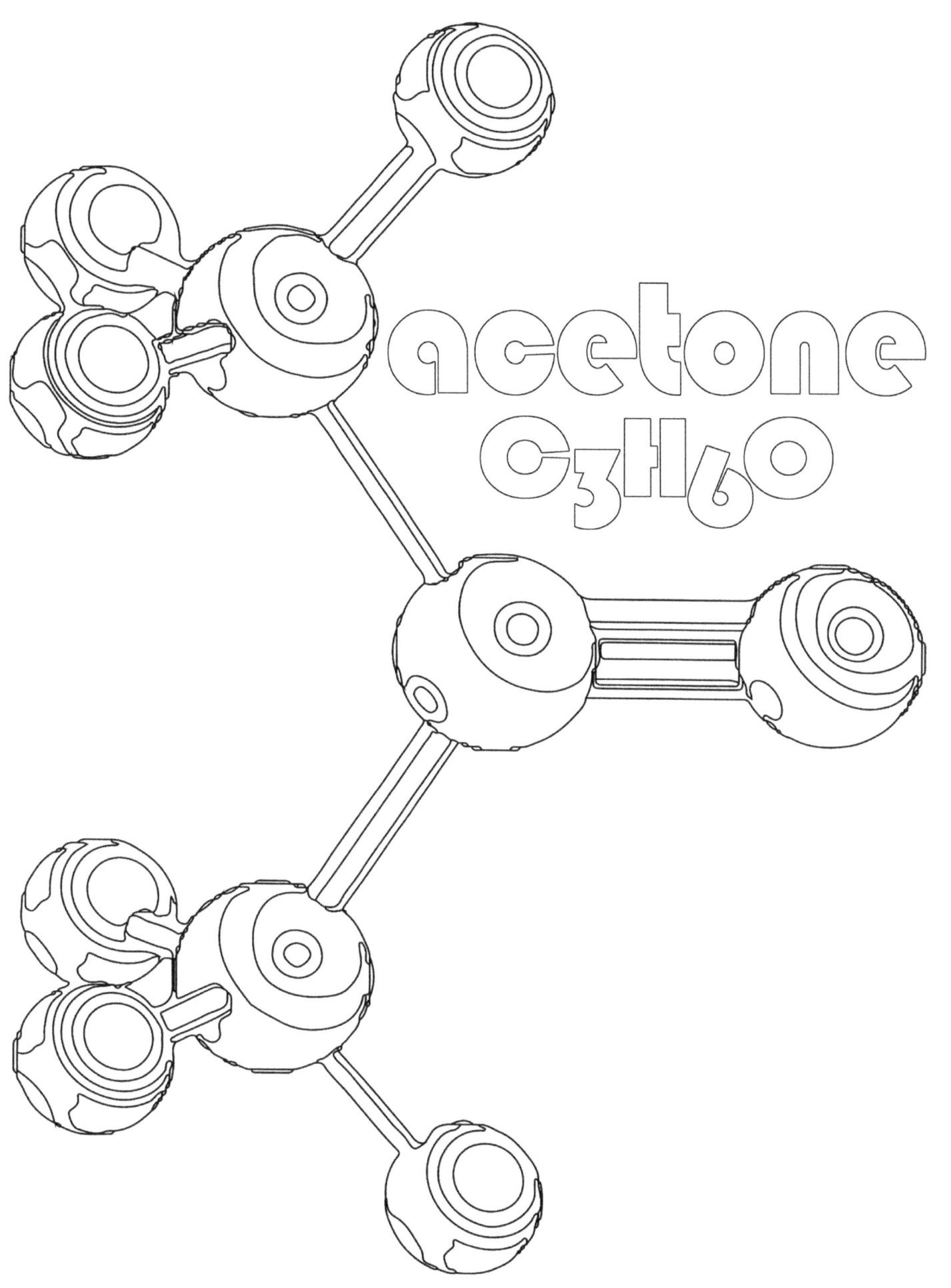

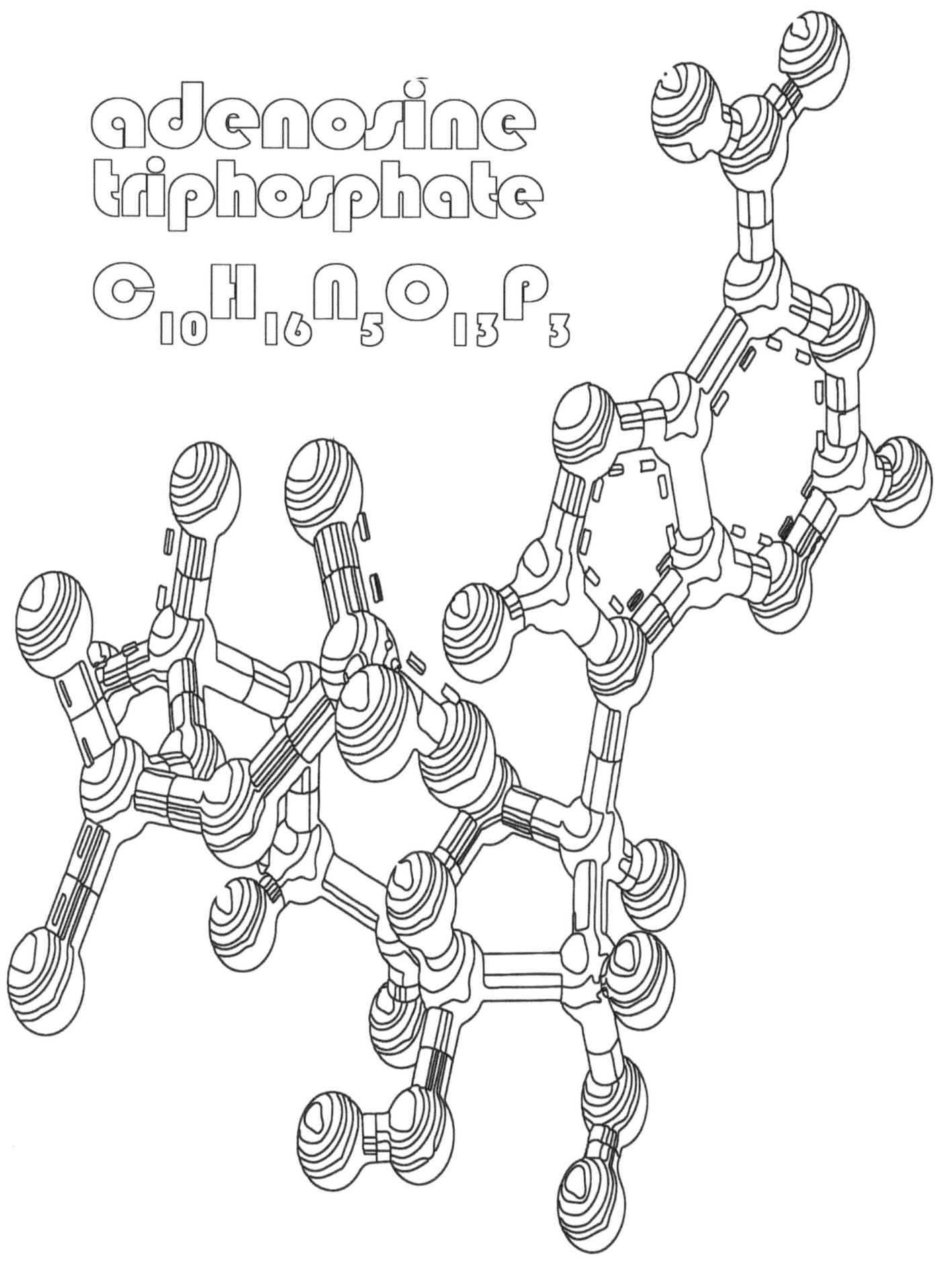

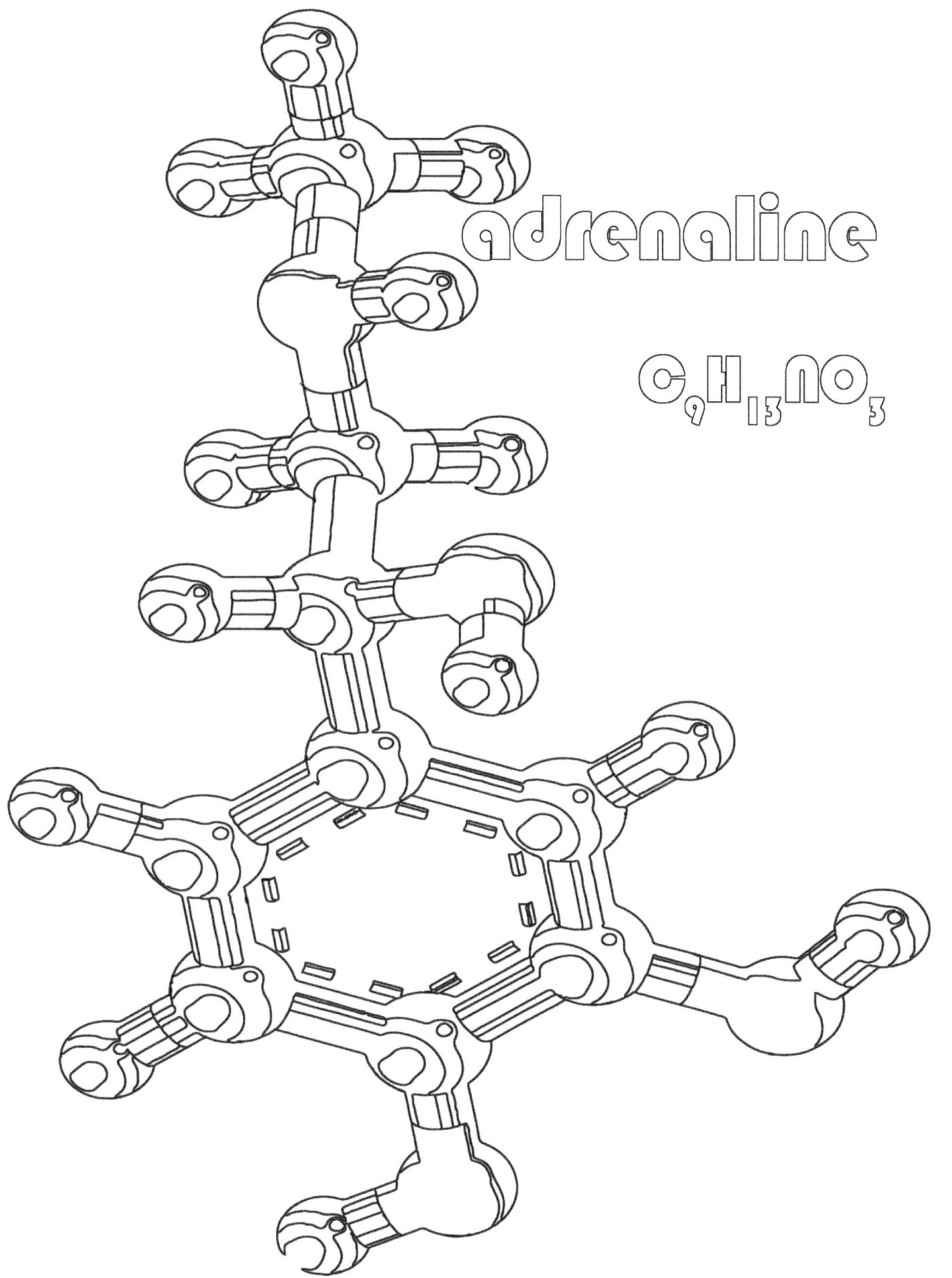

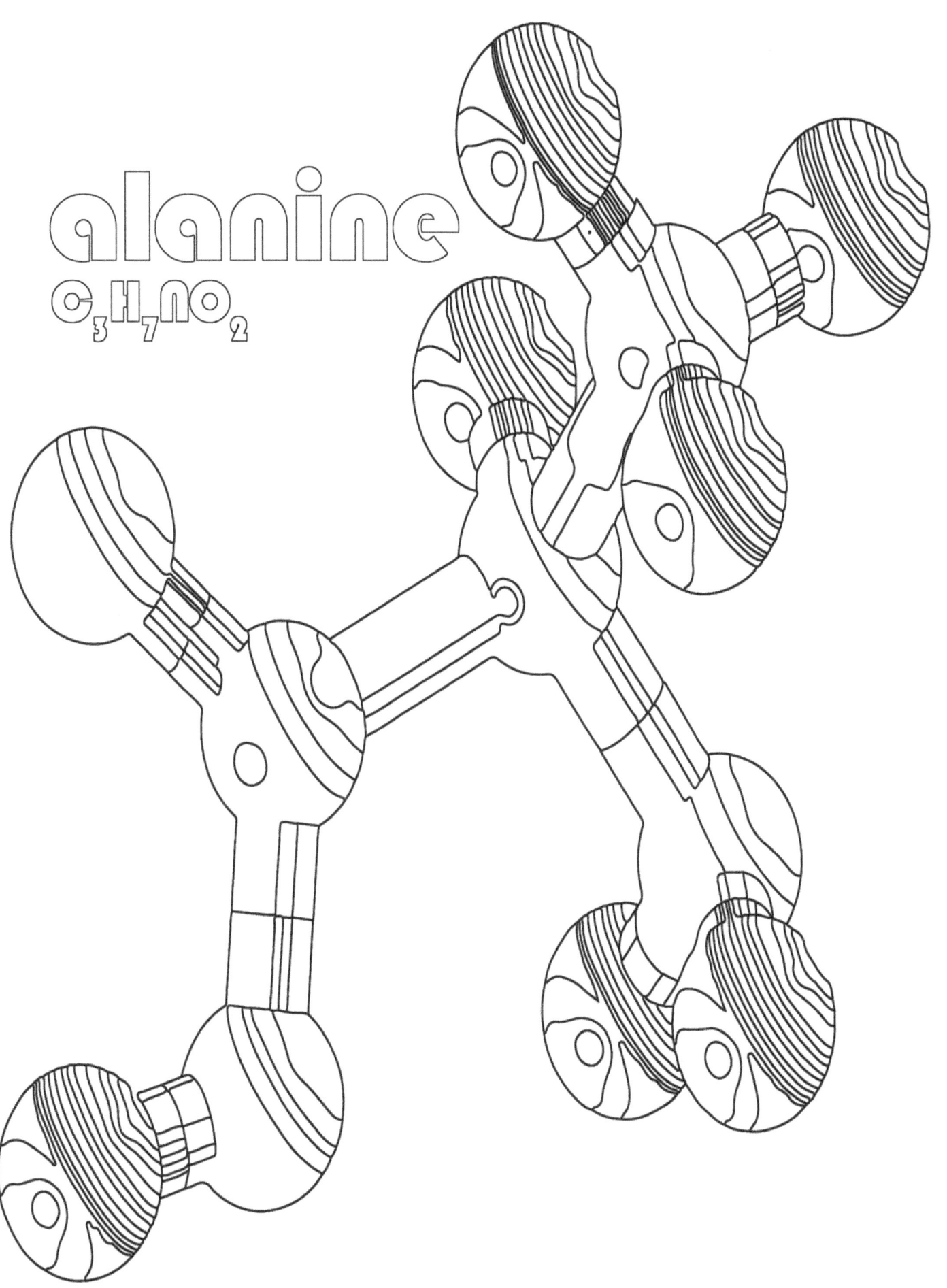

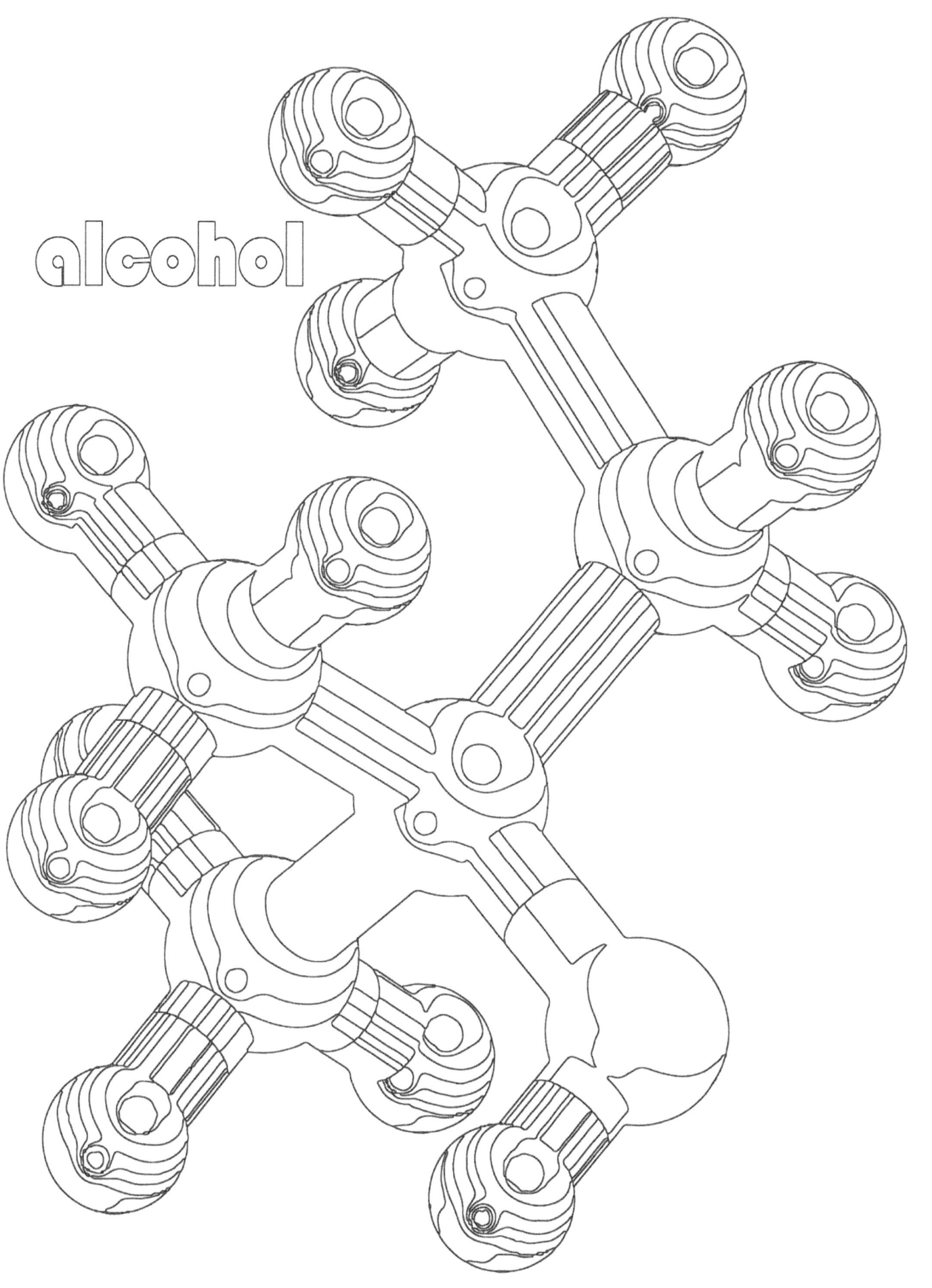

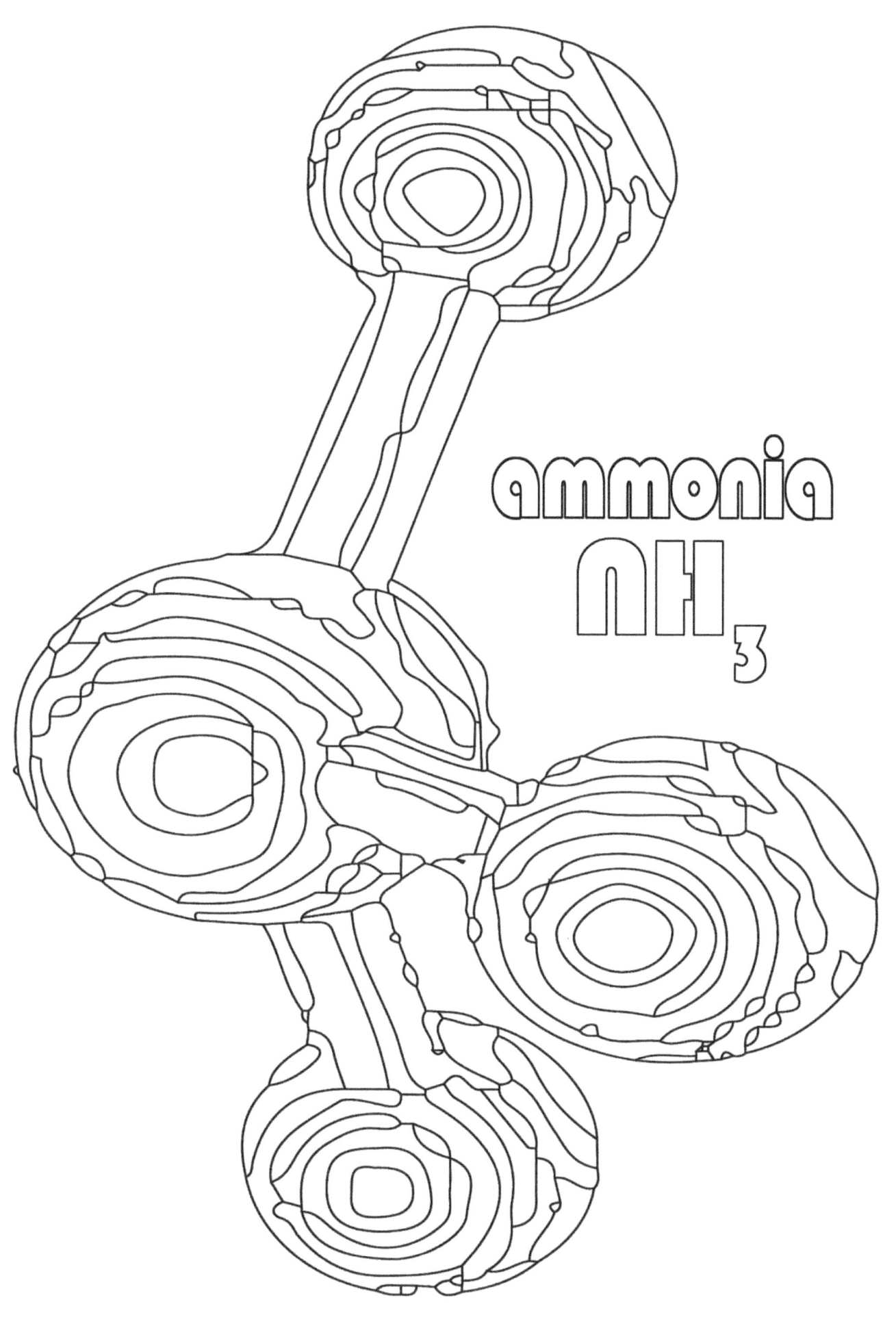

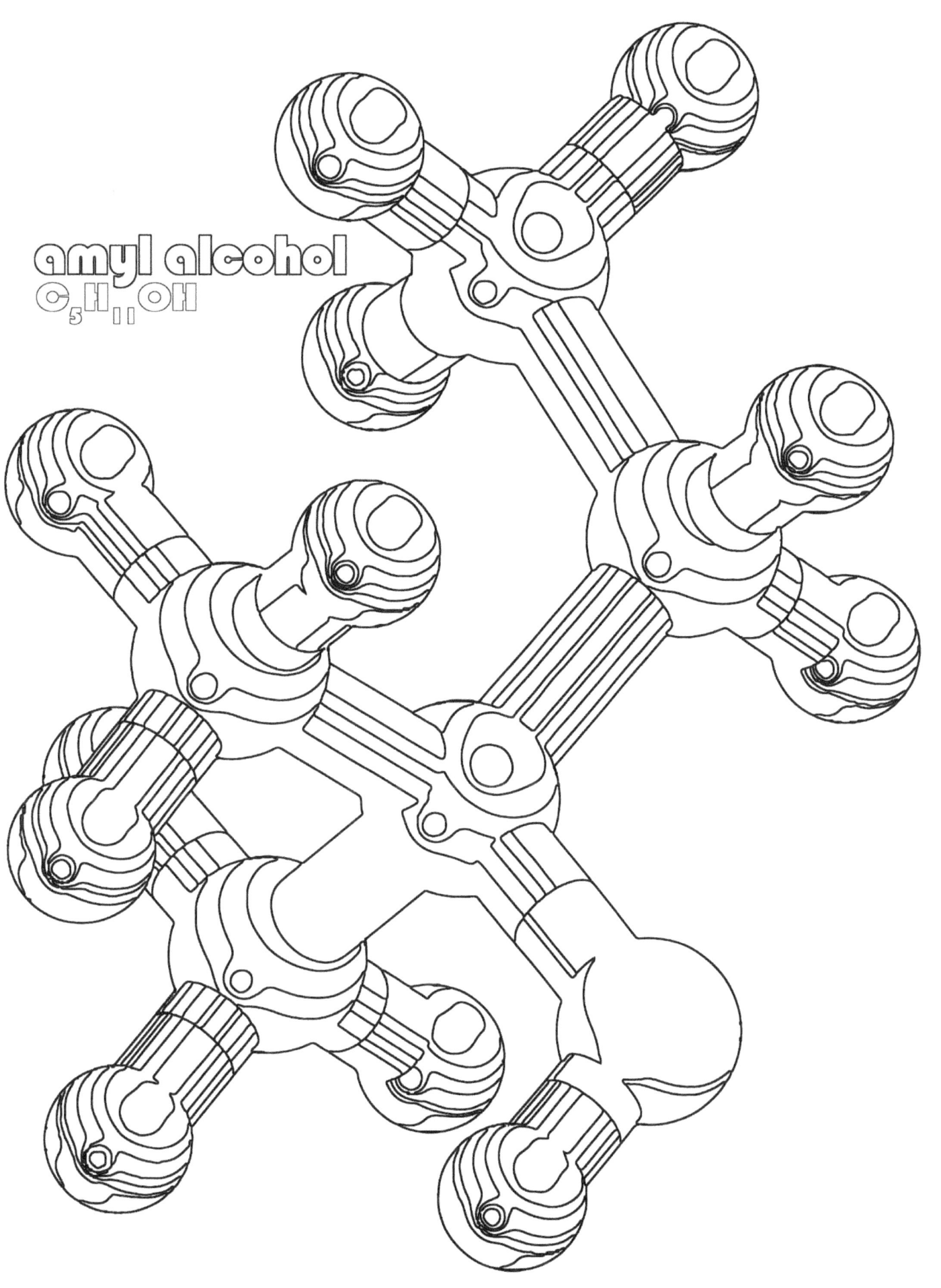

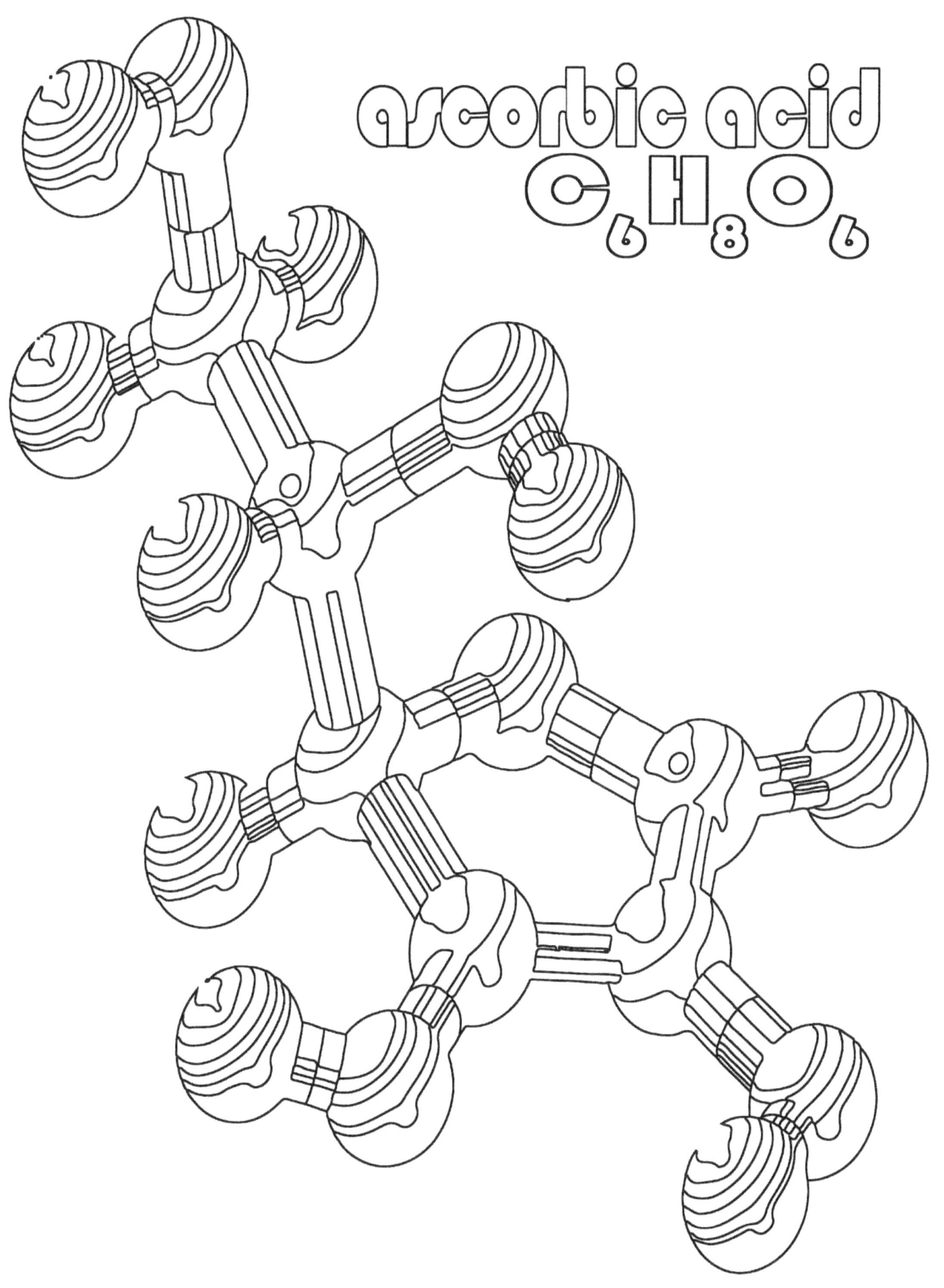

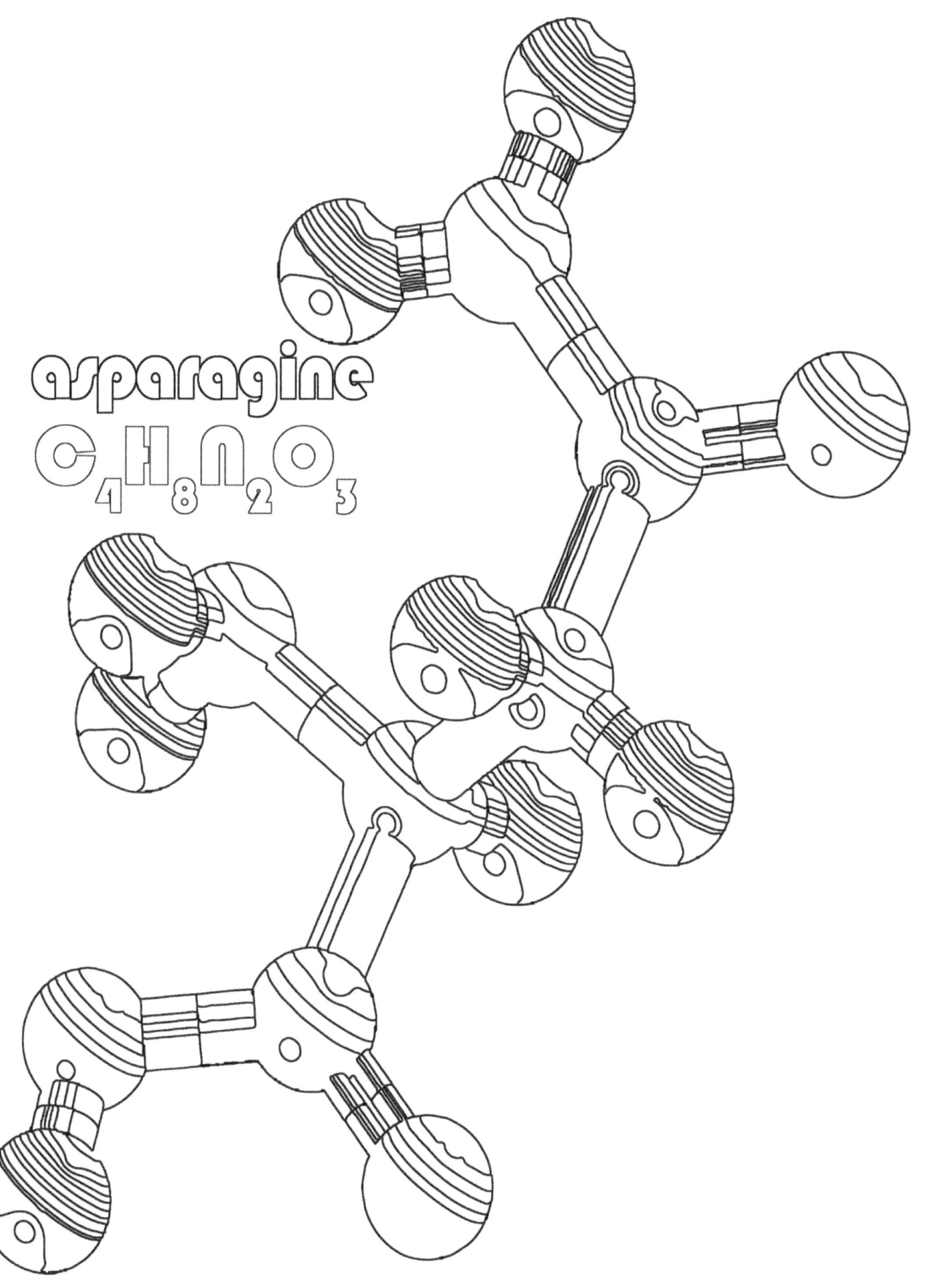

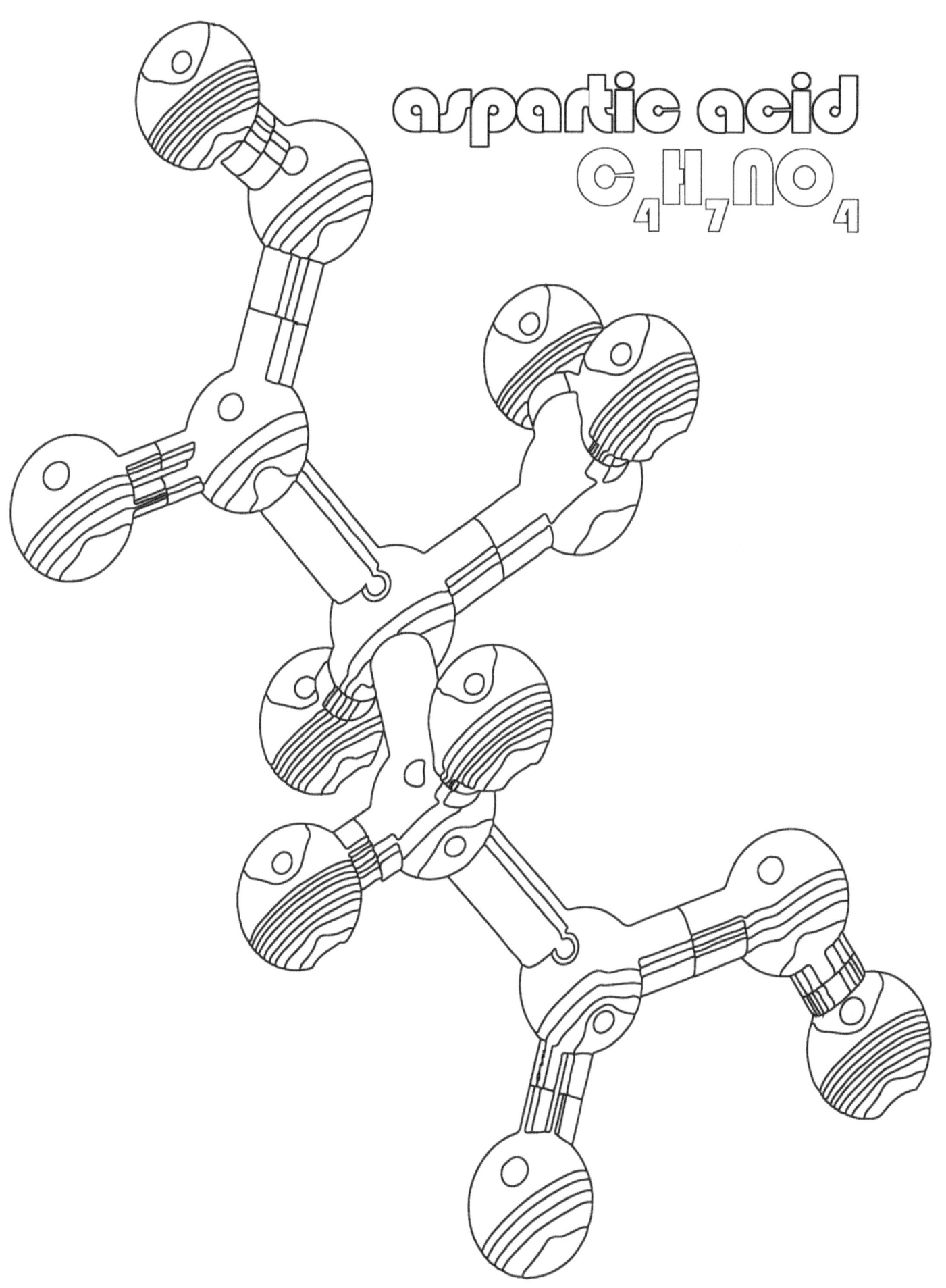

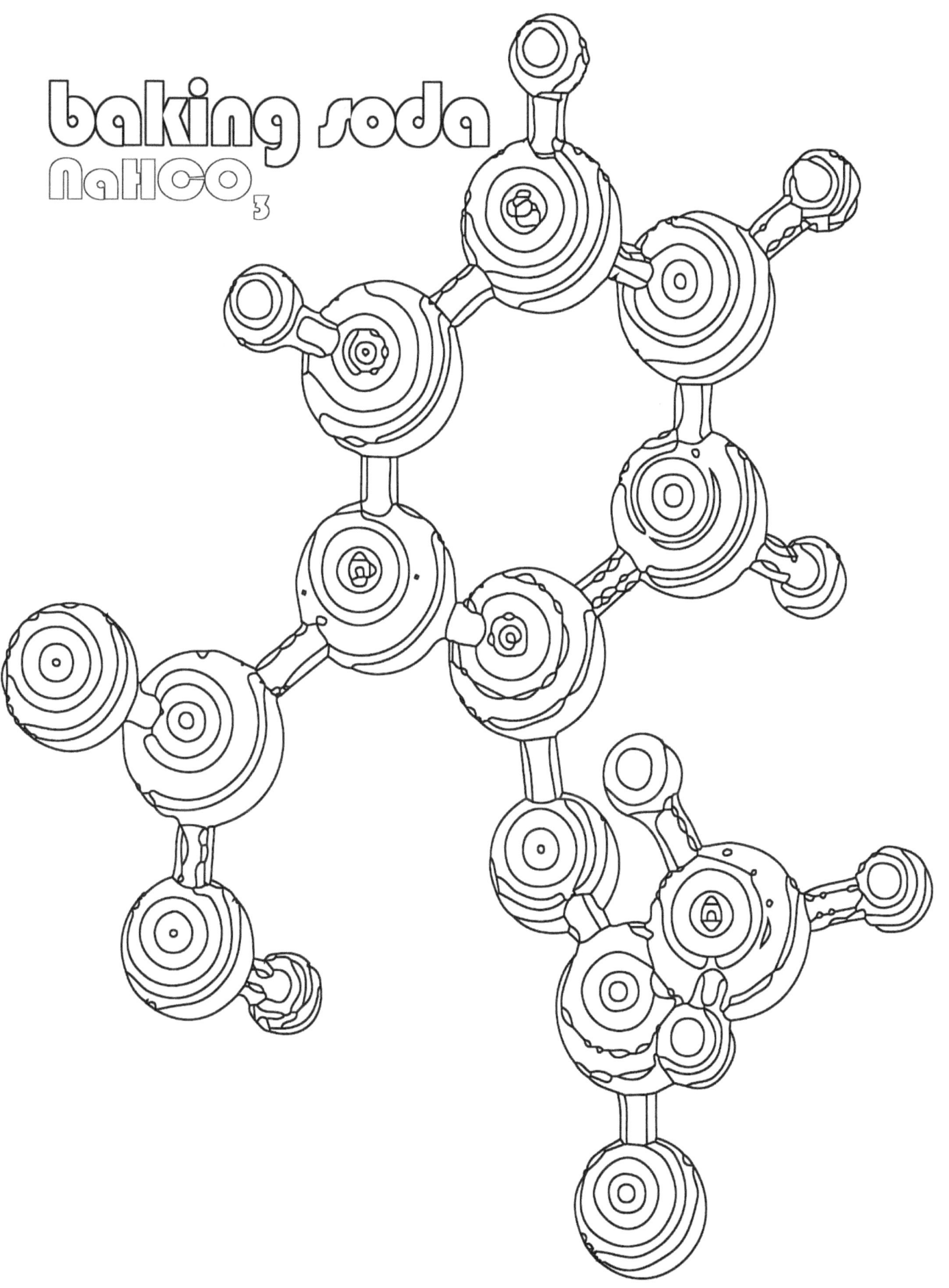

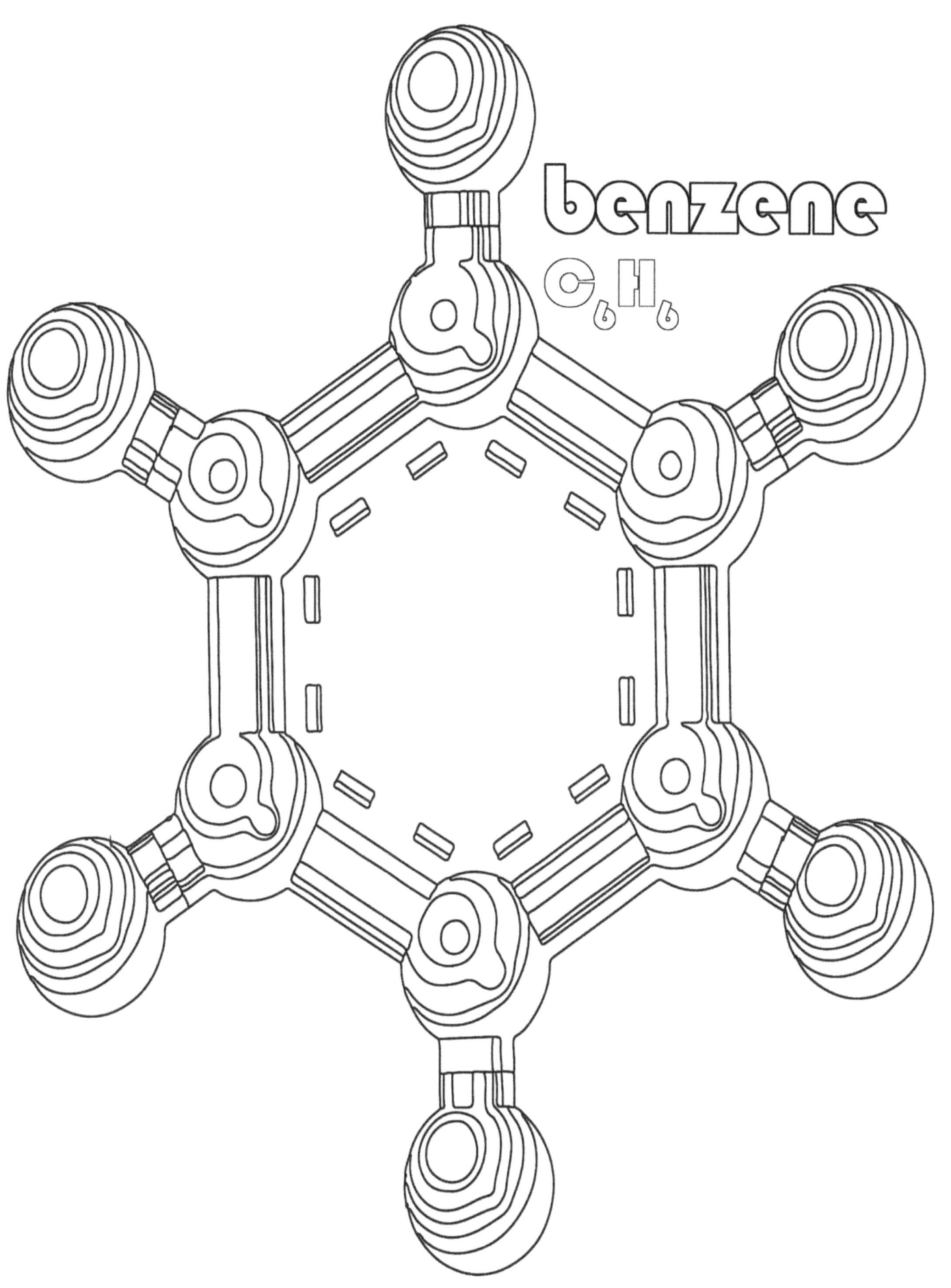

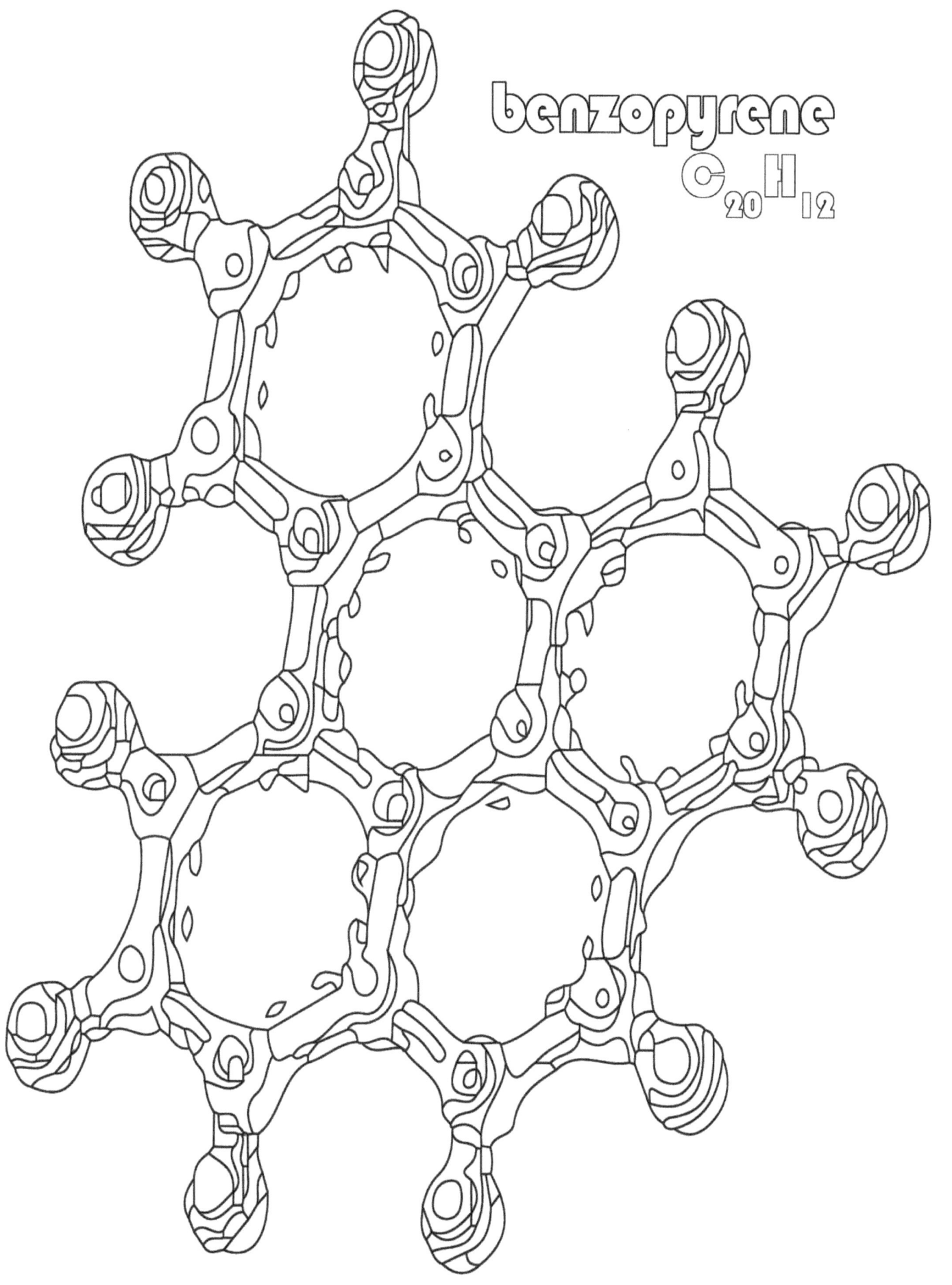

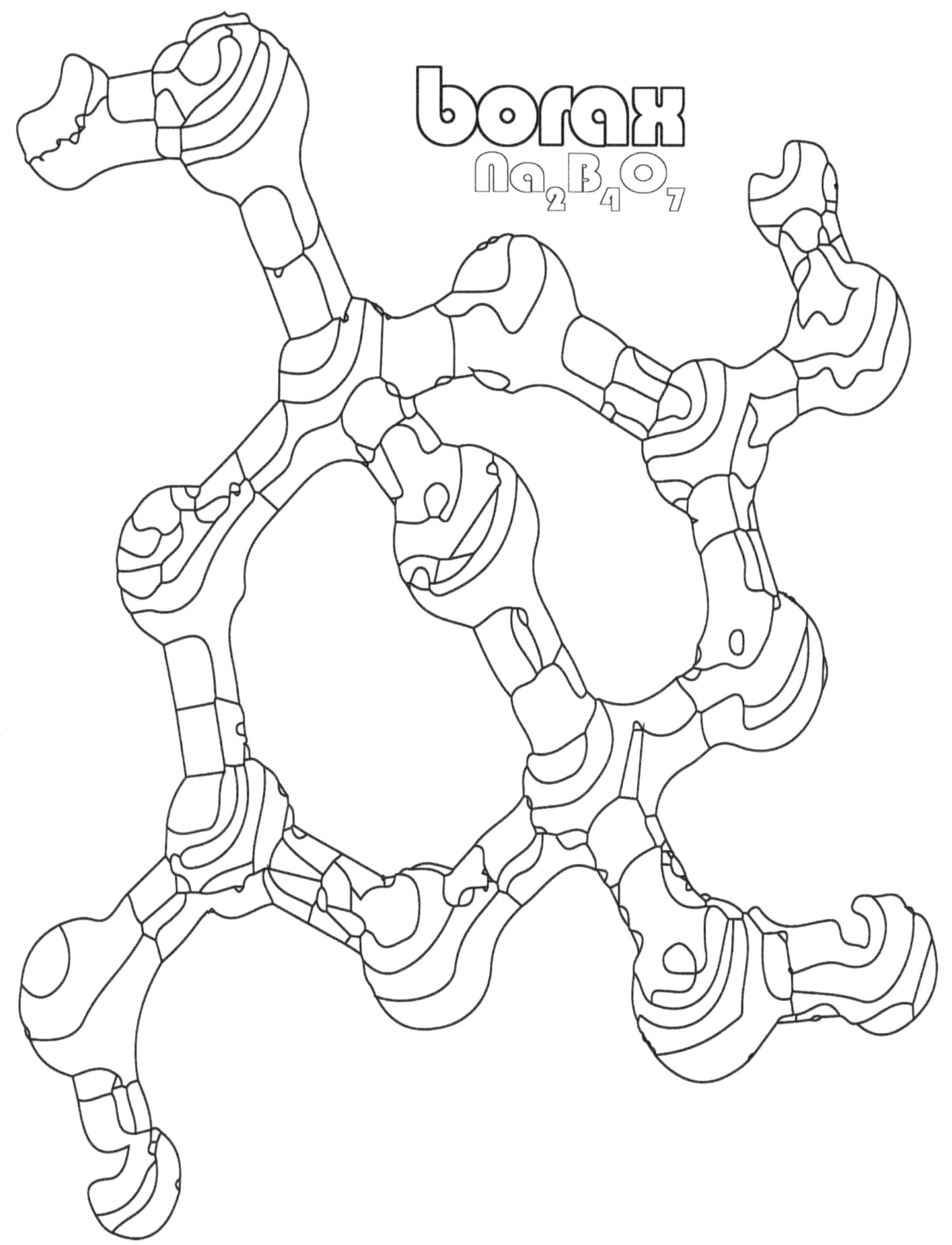

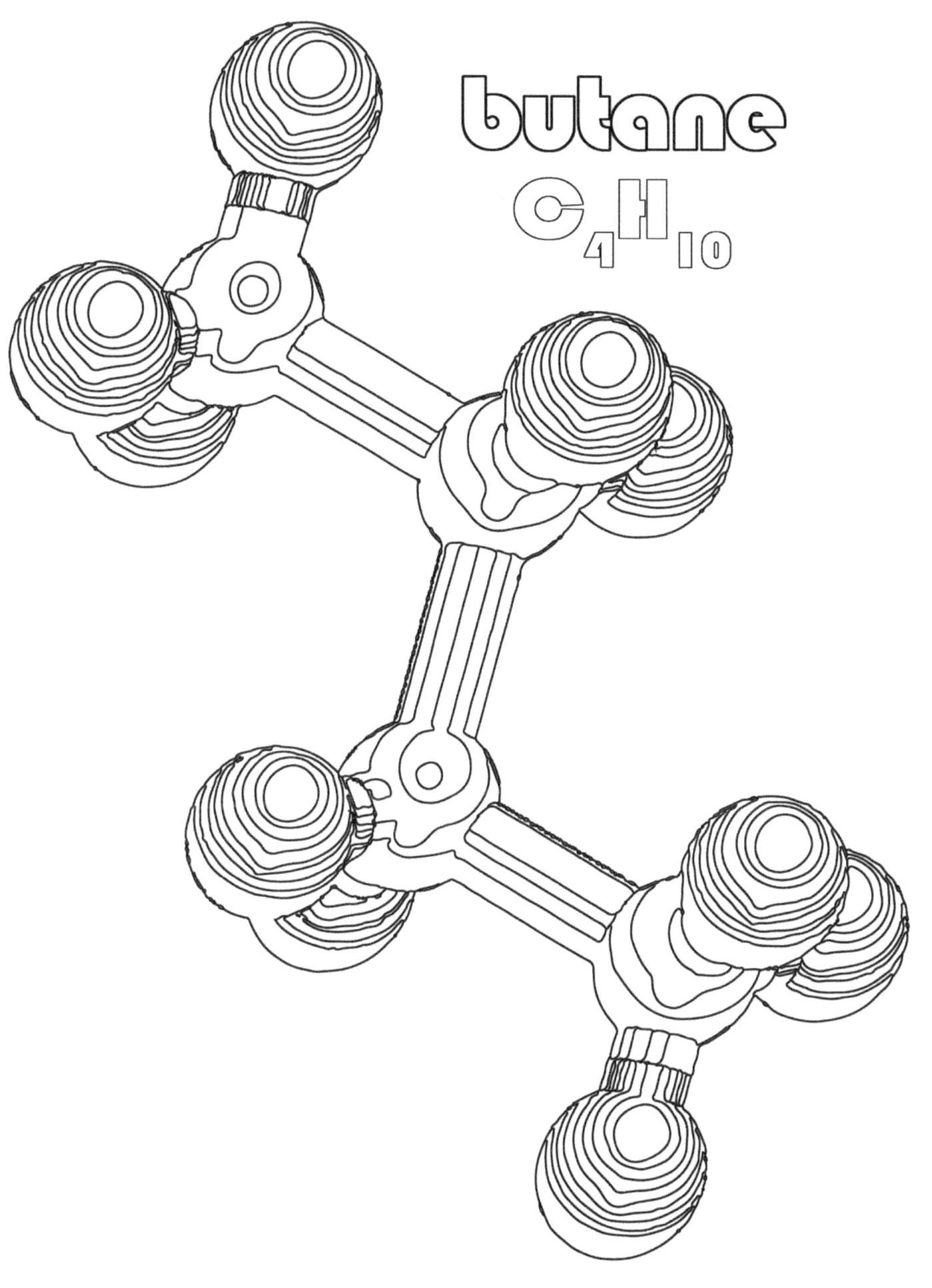

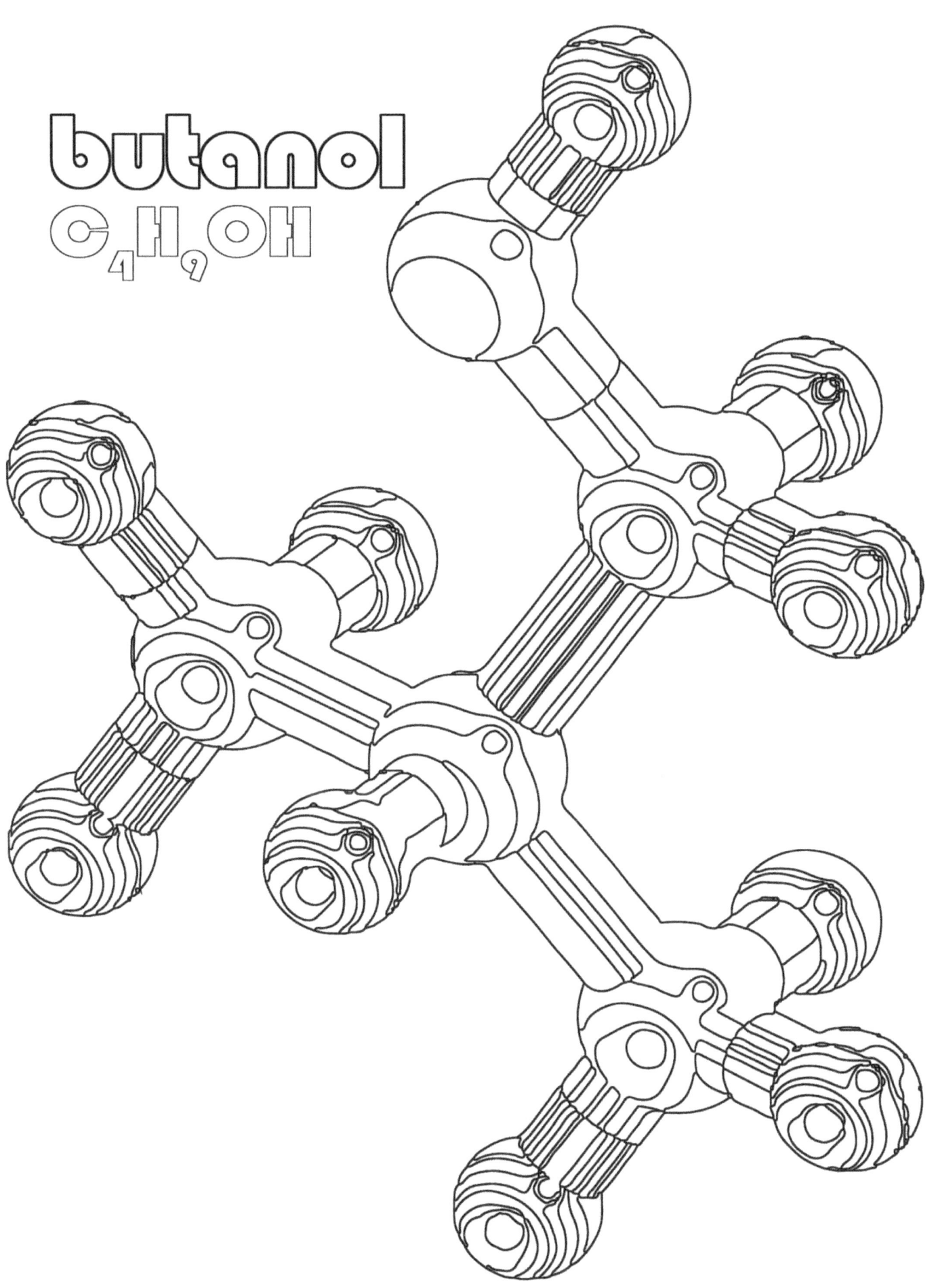

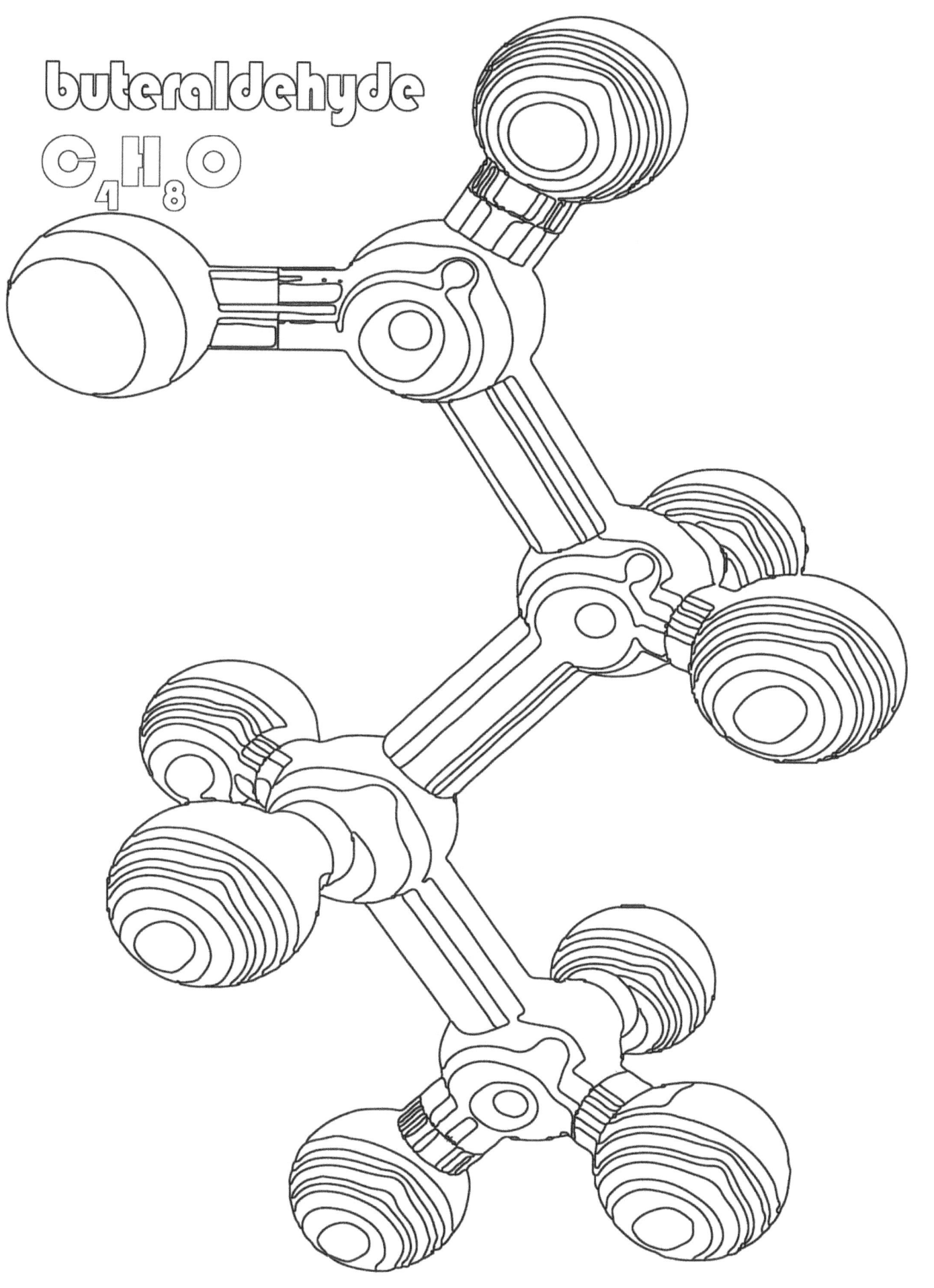

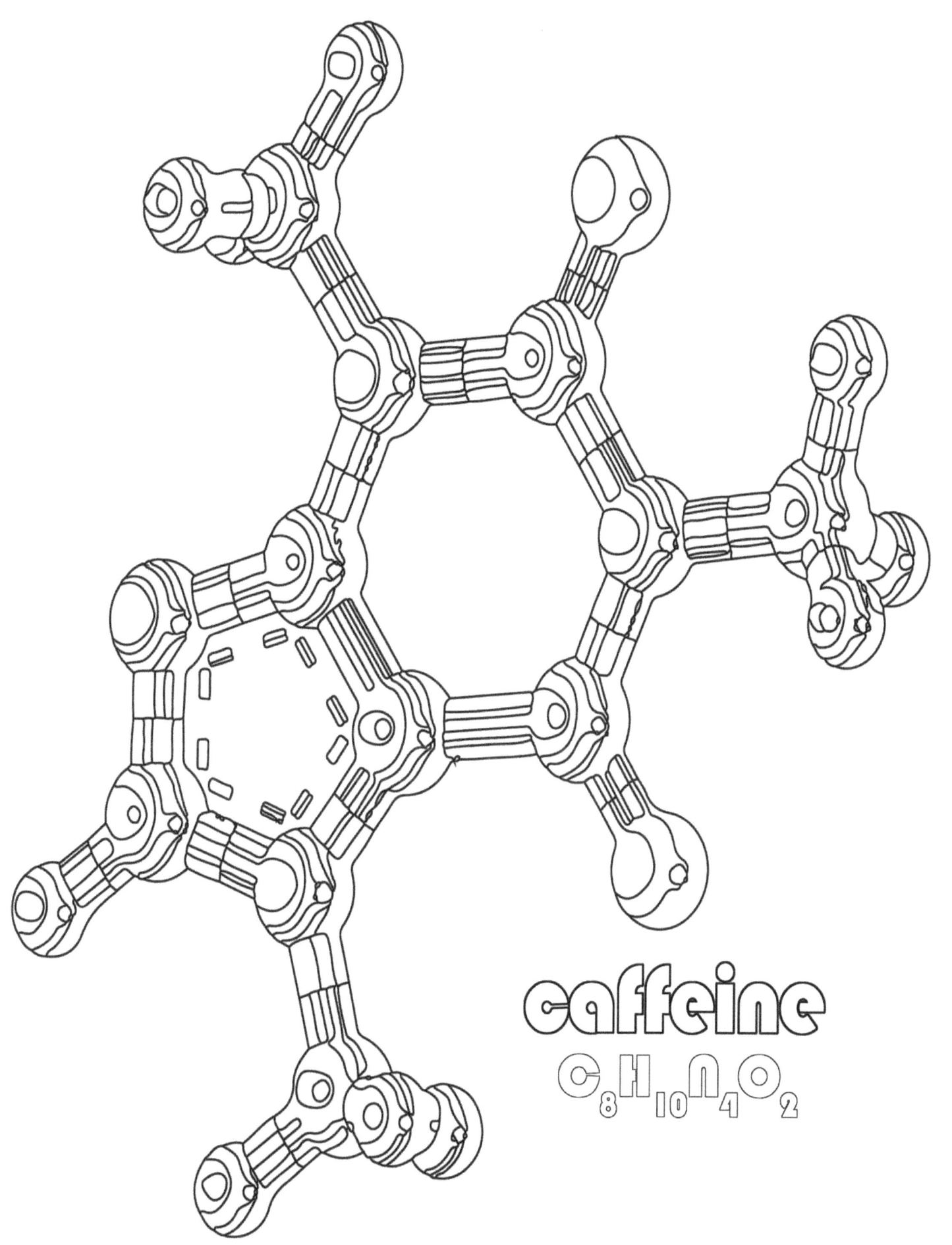

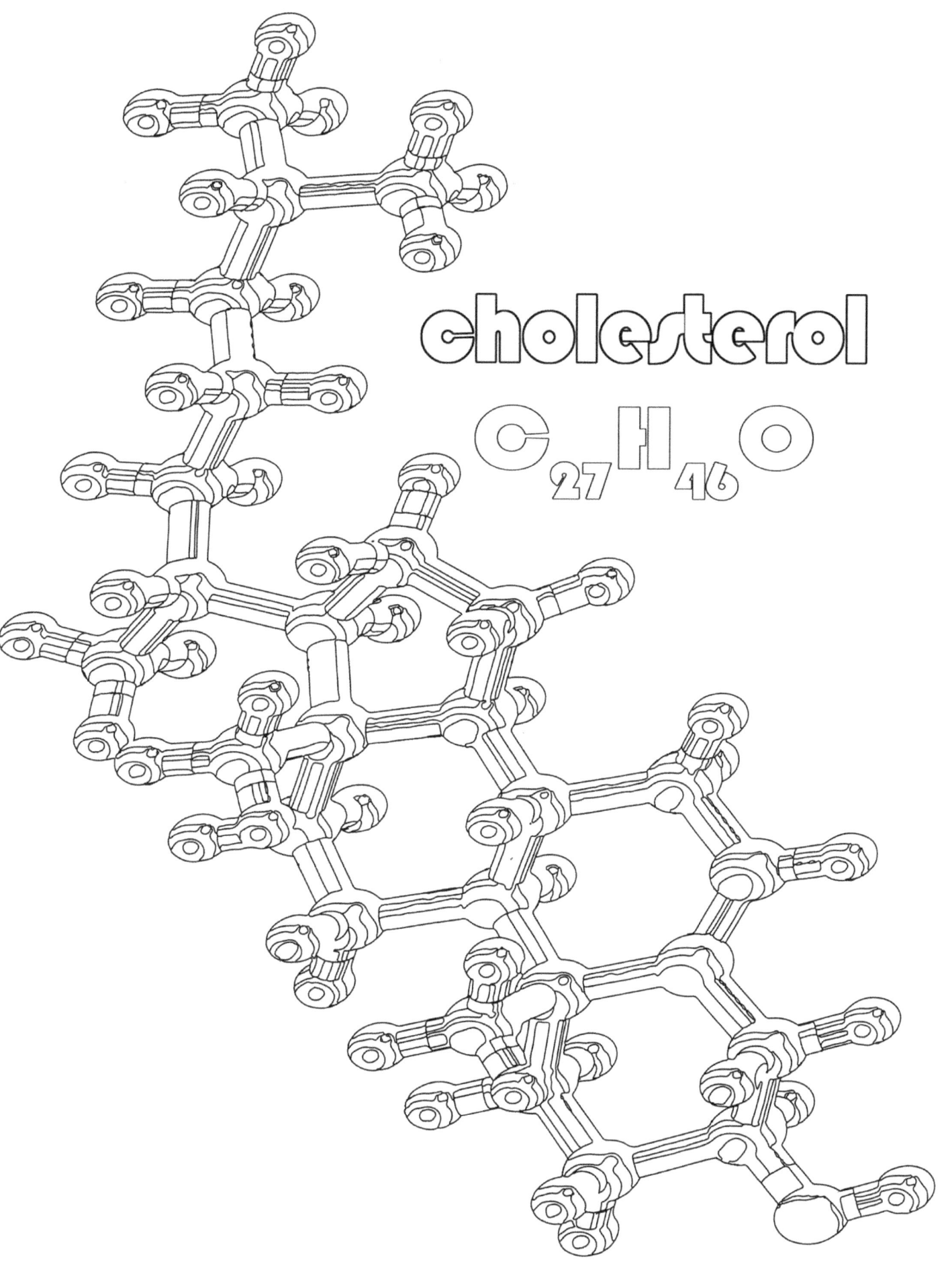

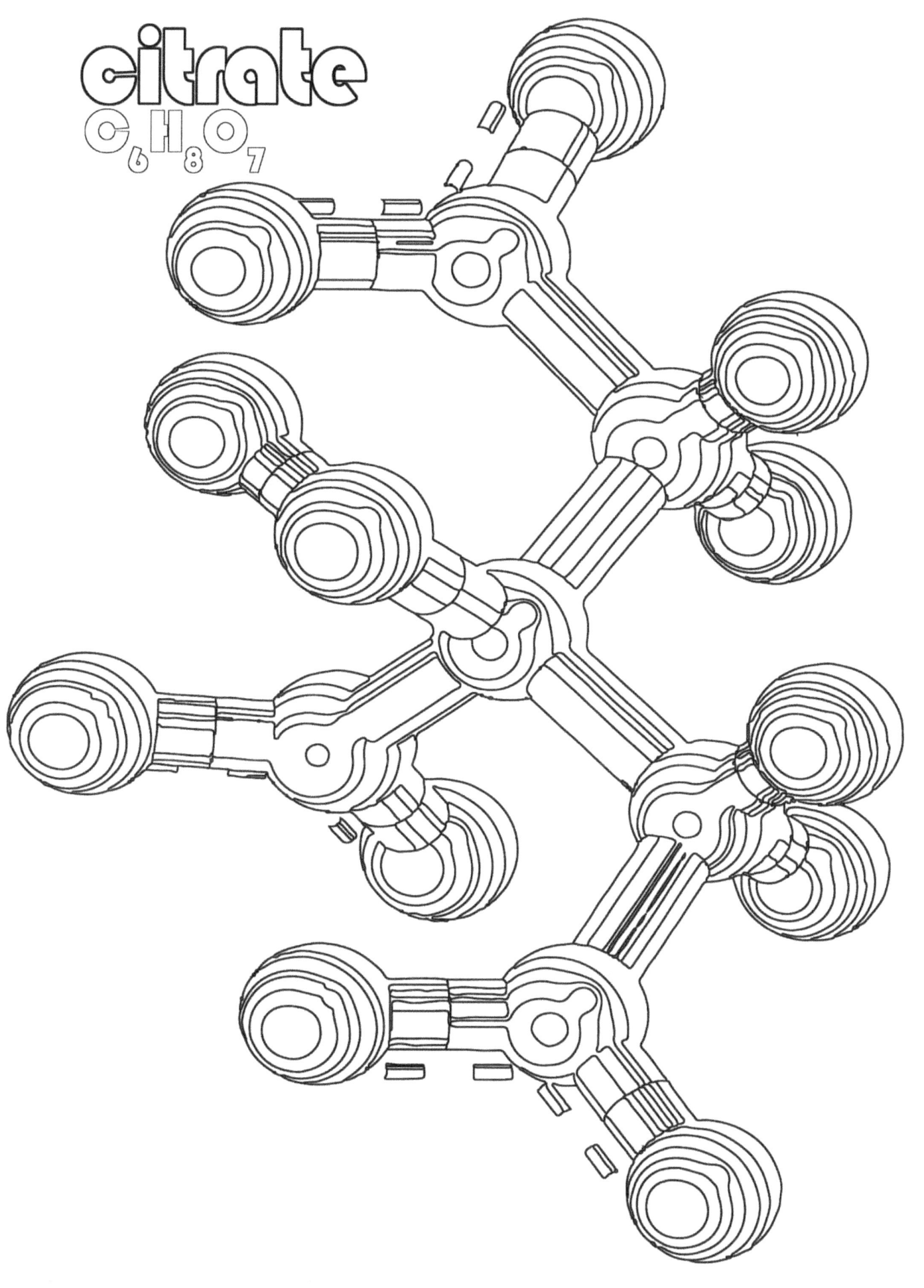

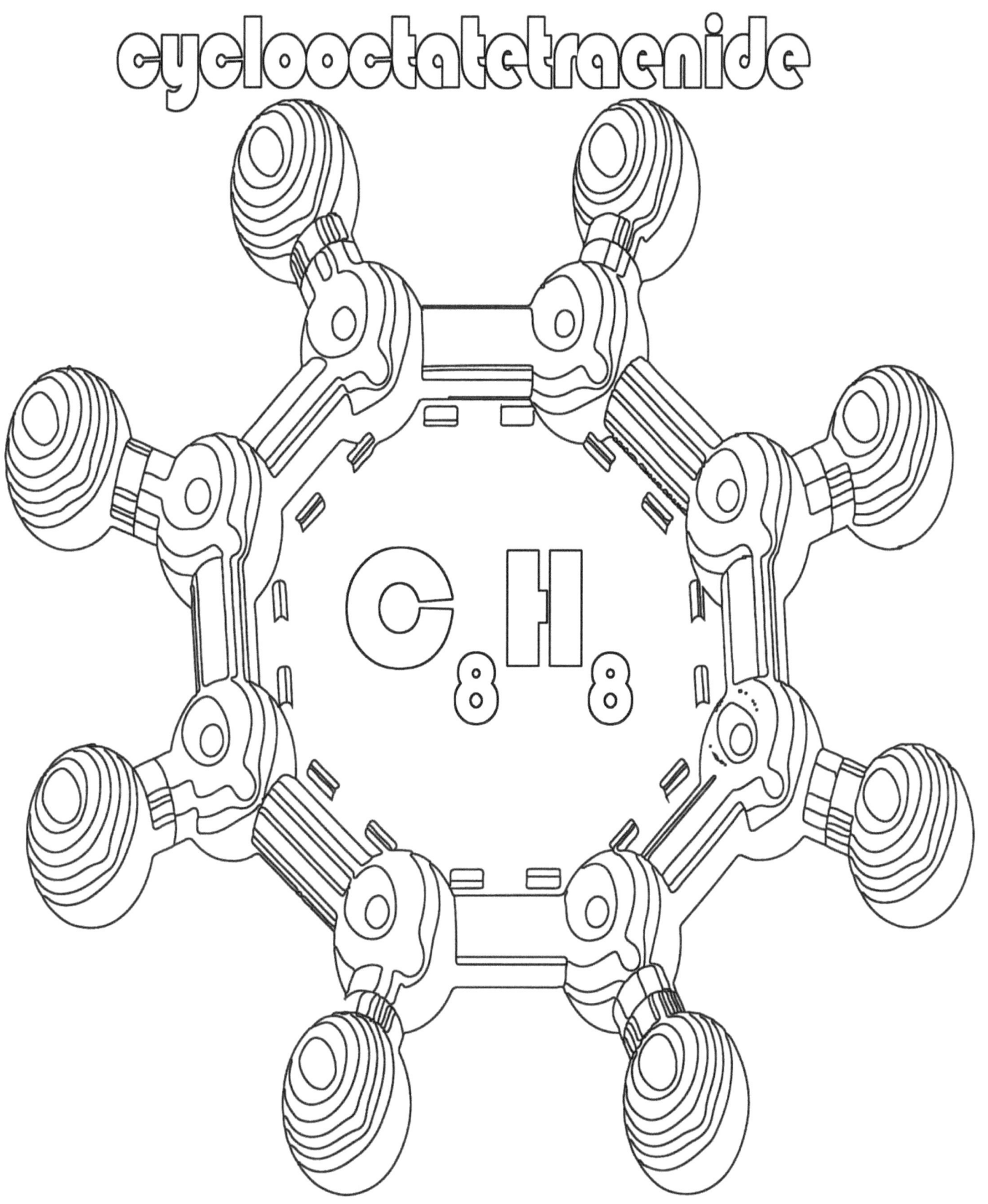

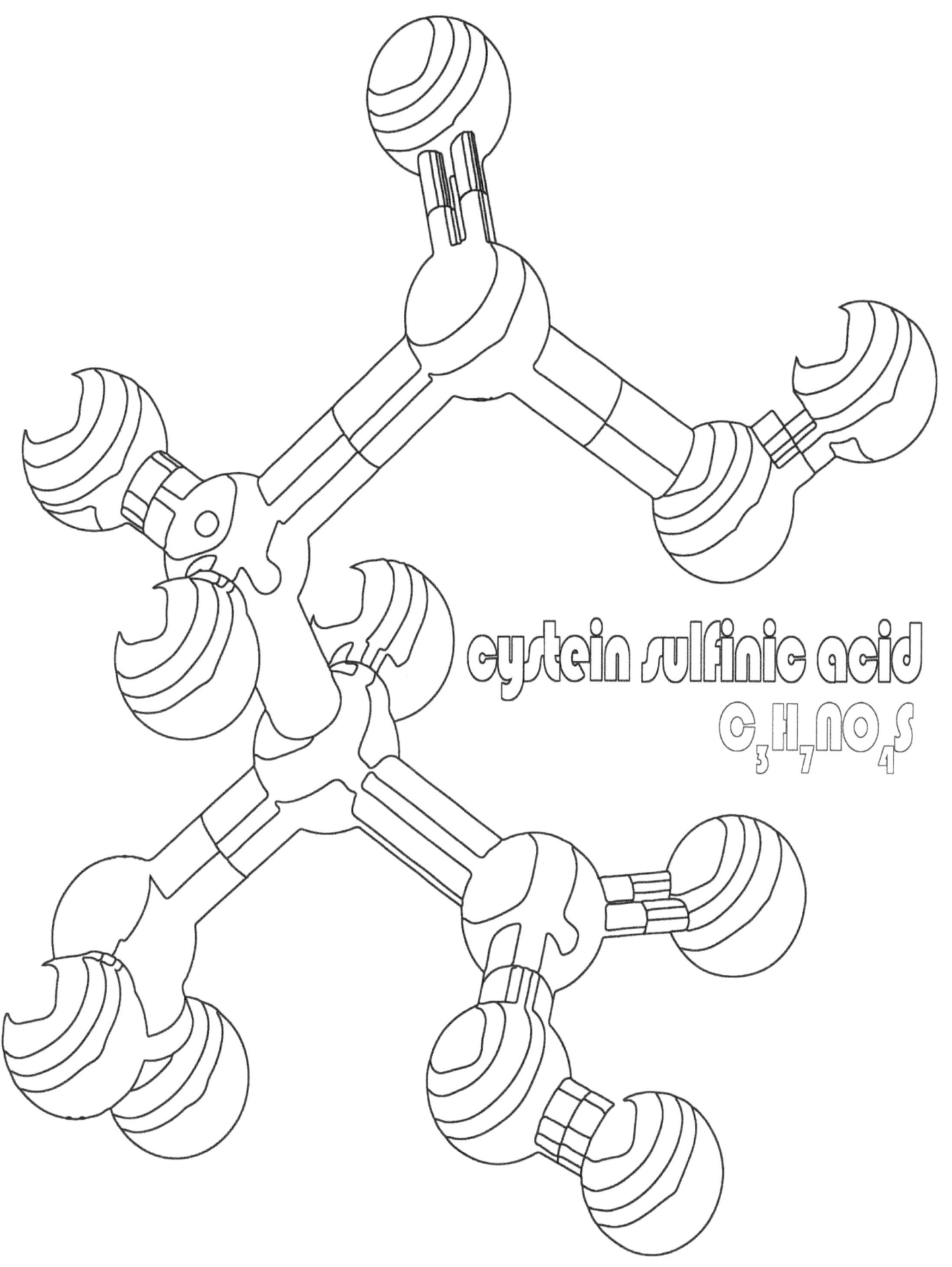

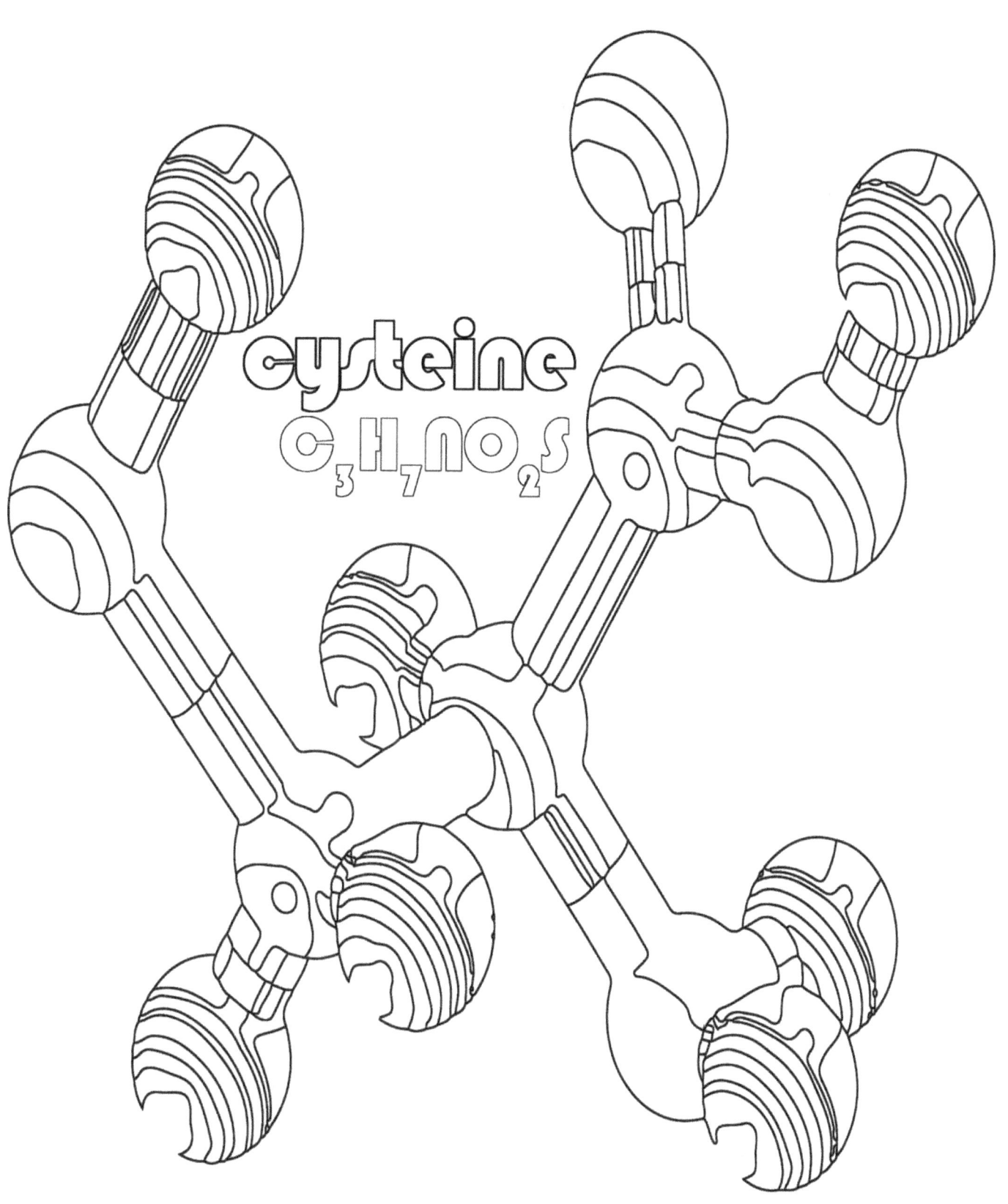

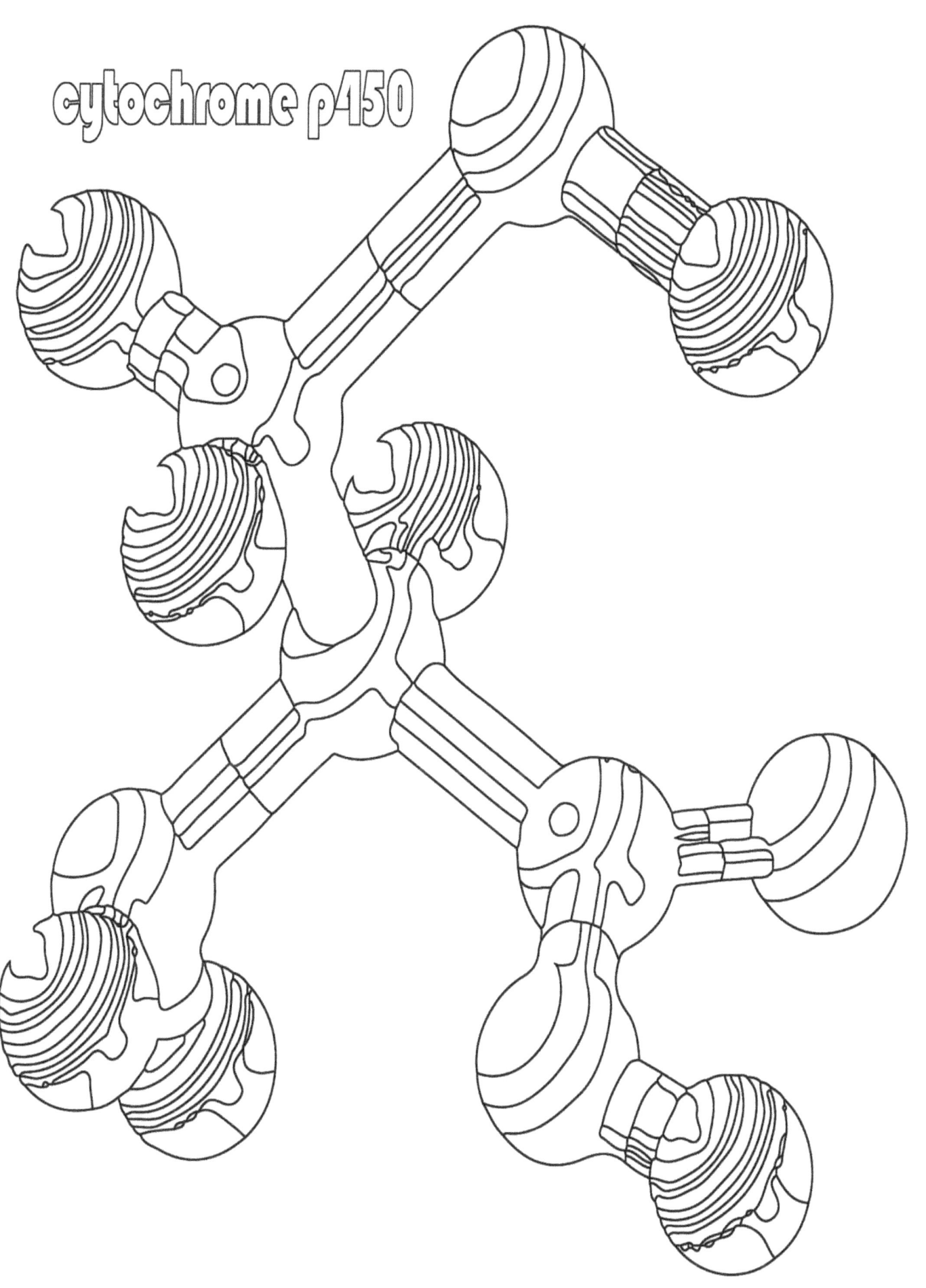

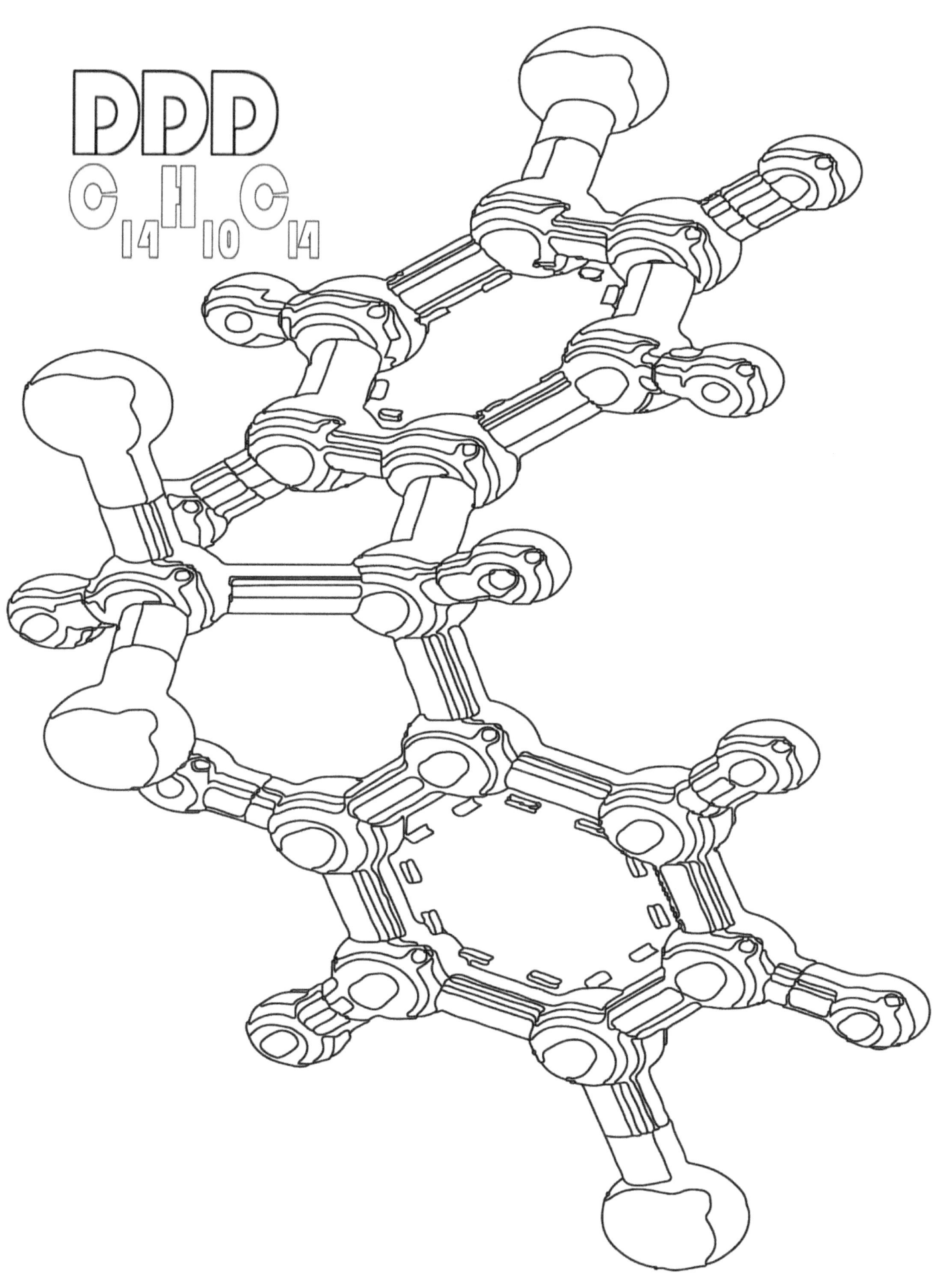

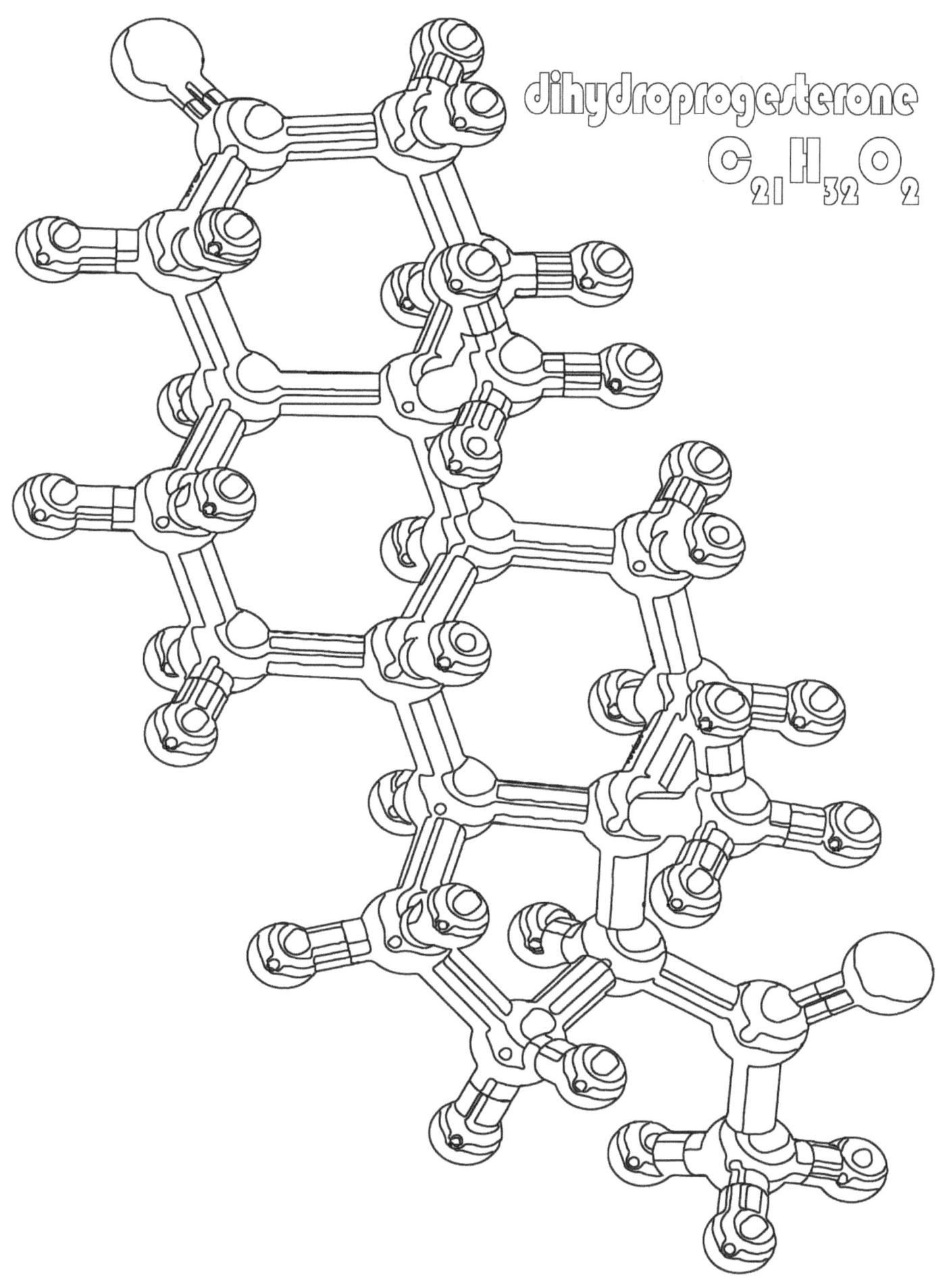

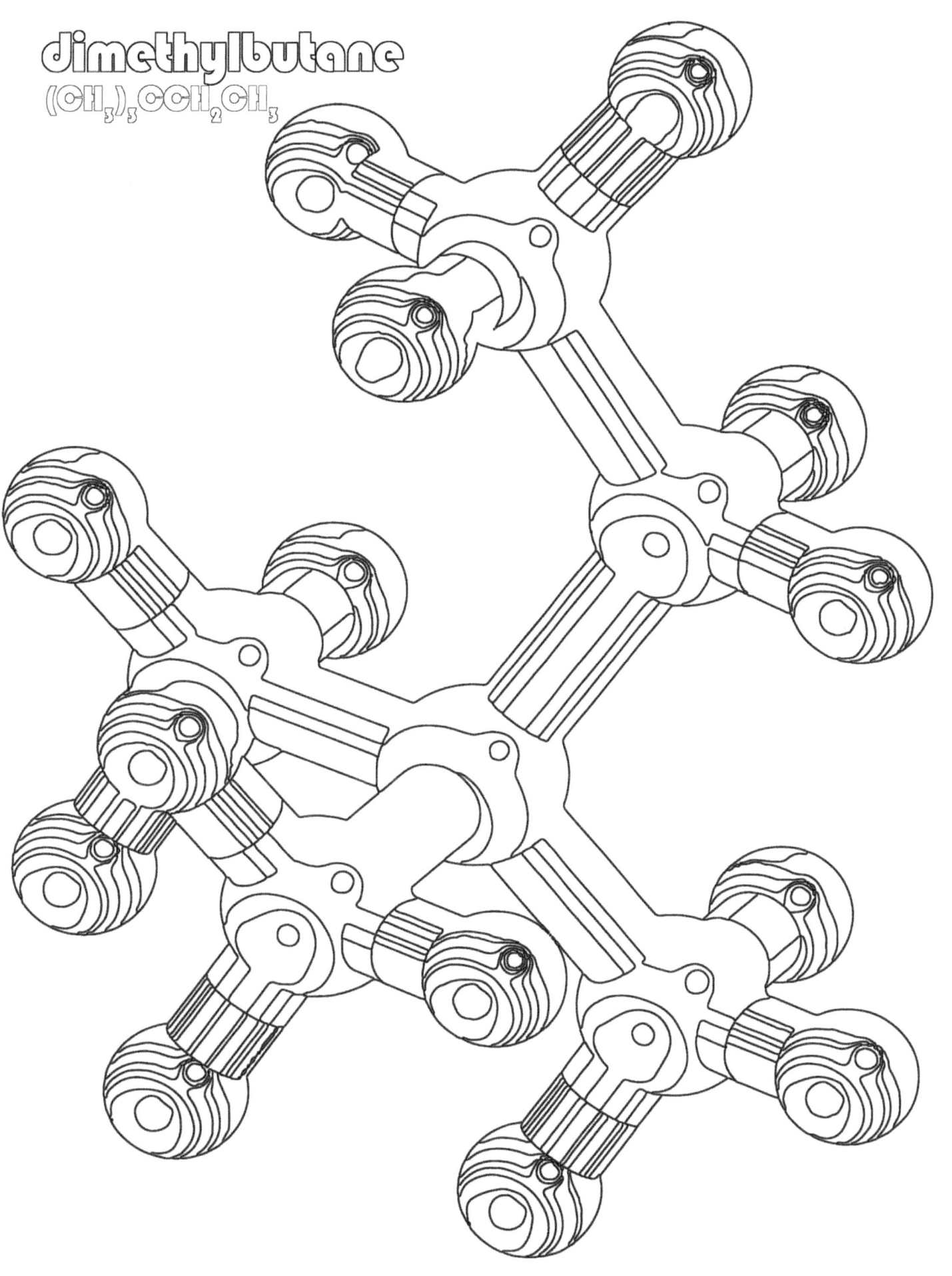

dimethylbutane
$(CH_3)_3CCH_2CH_3$

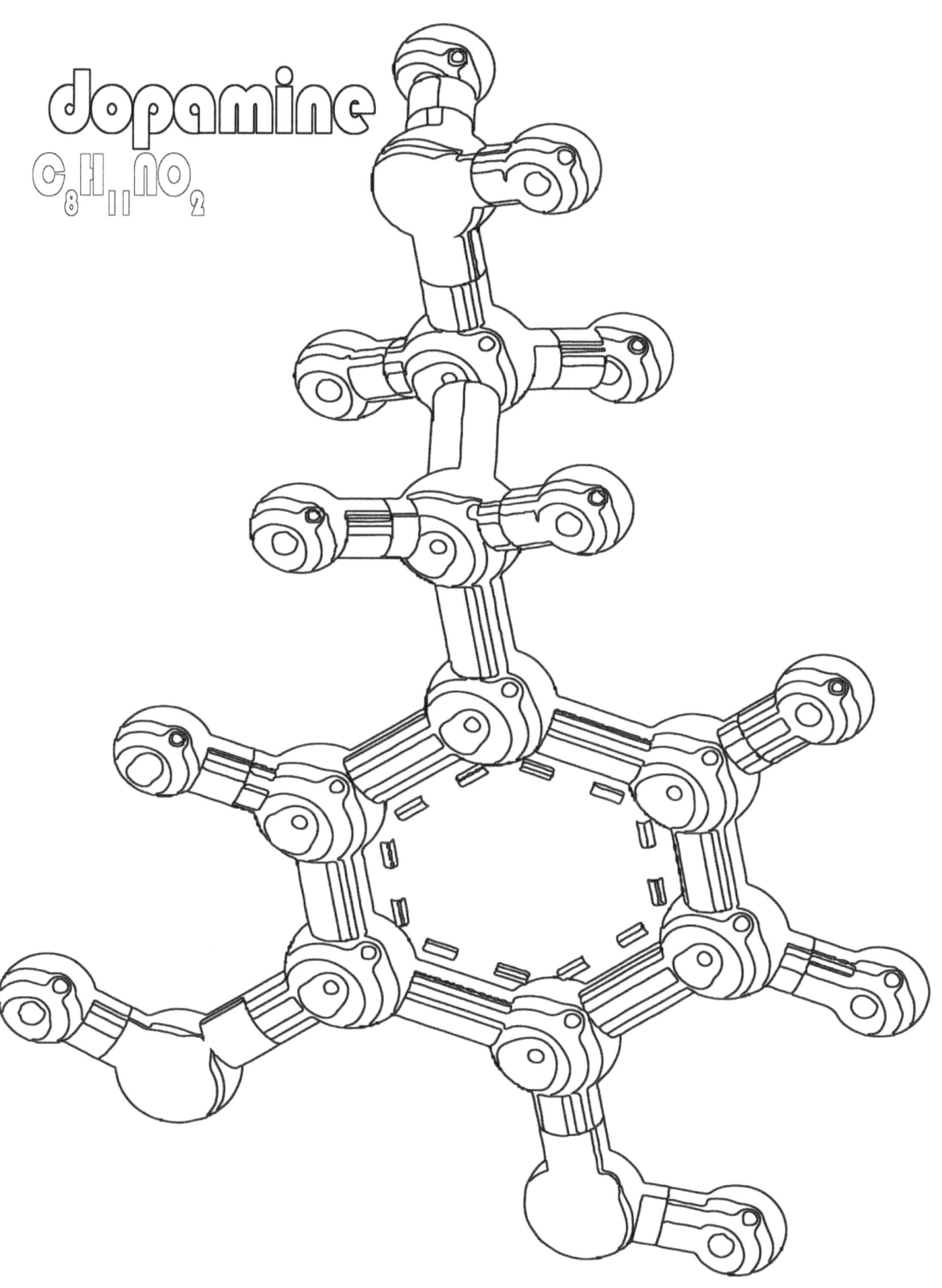

3-amino-5-nitrosalicylic acid
$C_7H_6N_2O_5$

2-amino-3-carboxy muconic-semialdehyde

$C_7H_7NO_5$

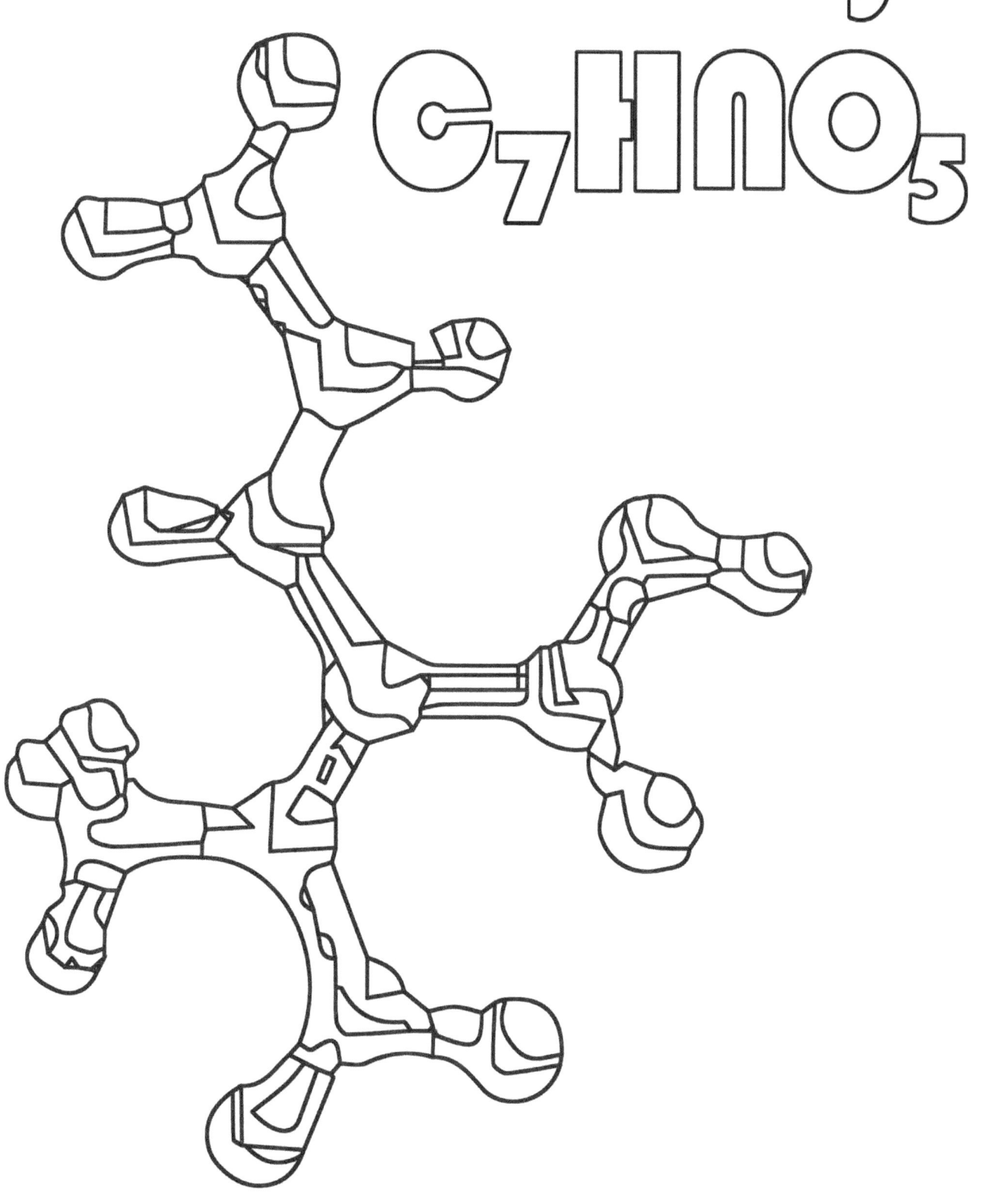

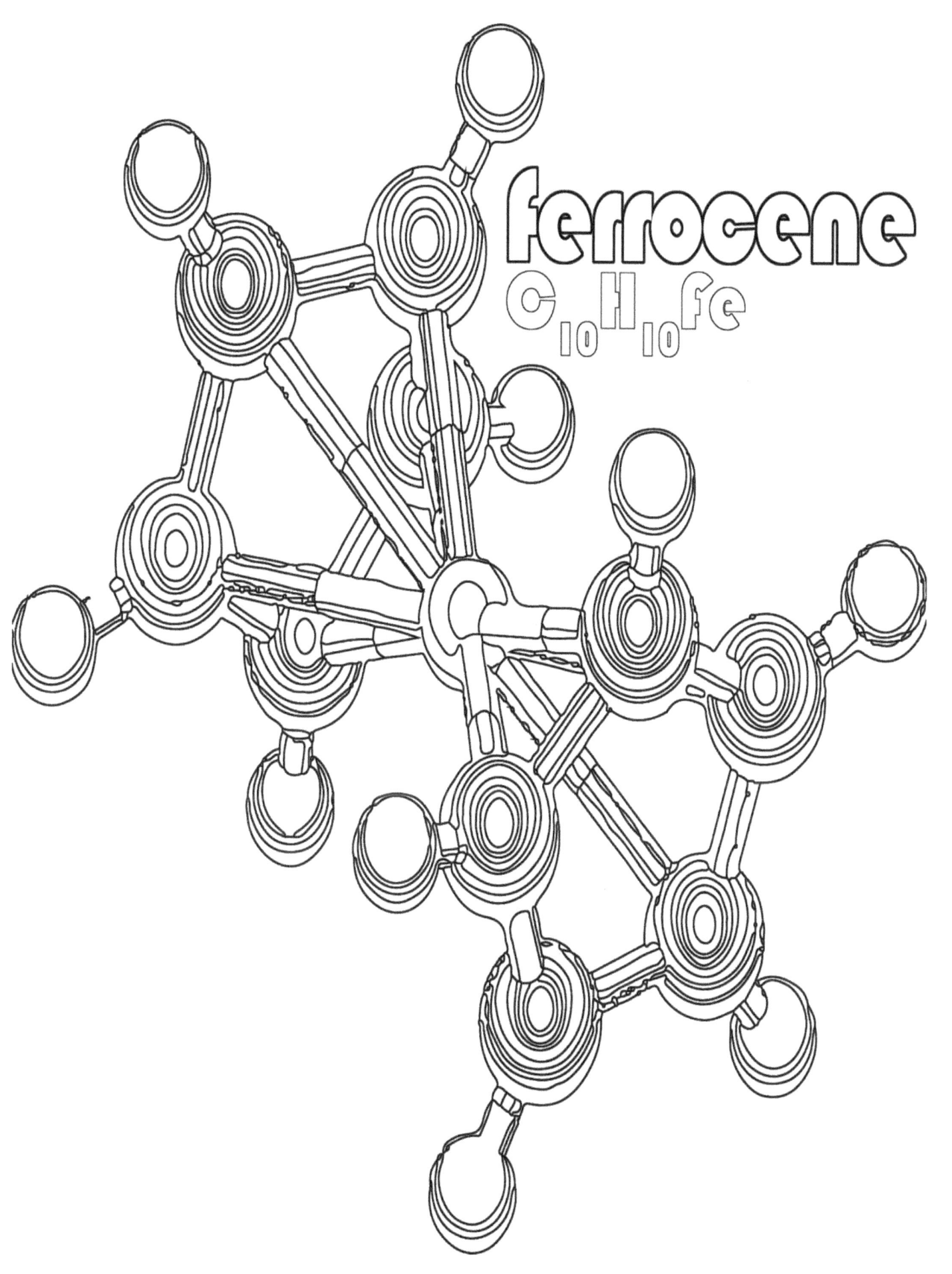

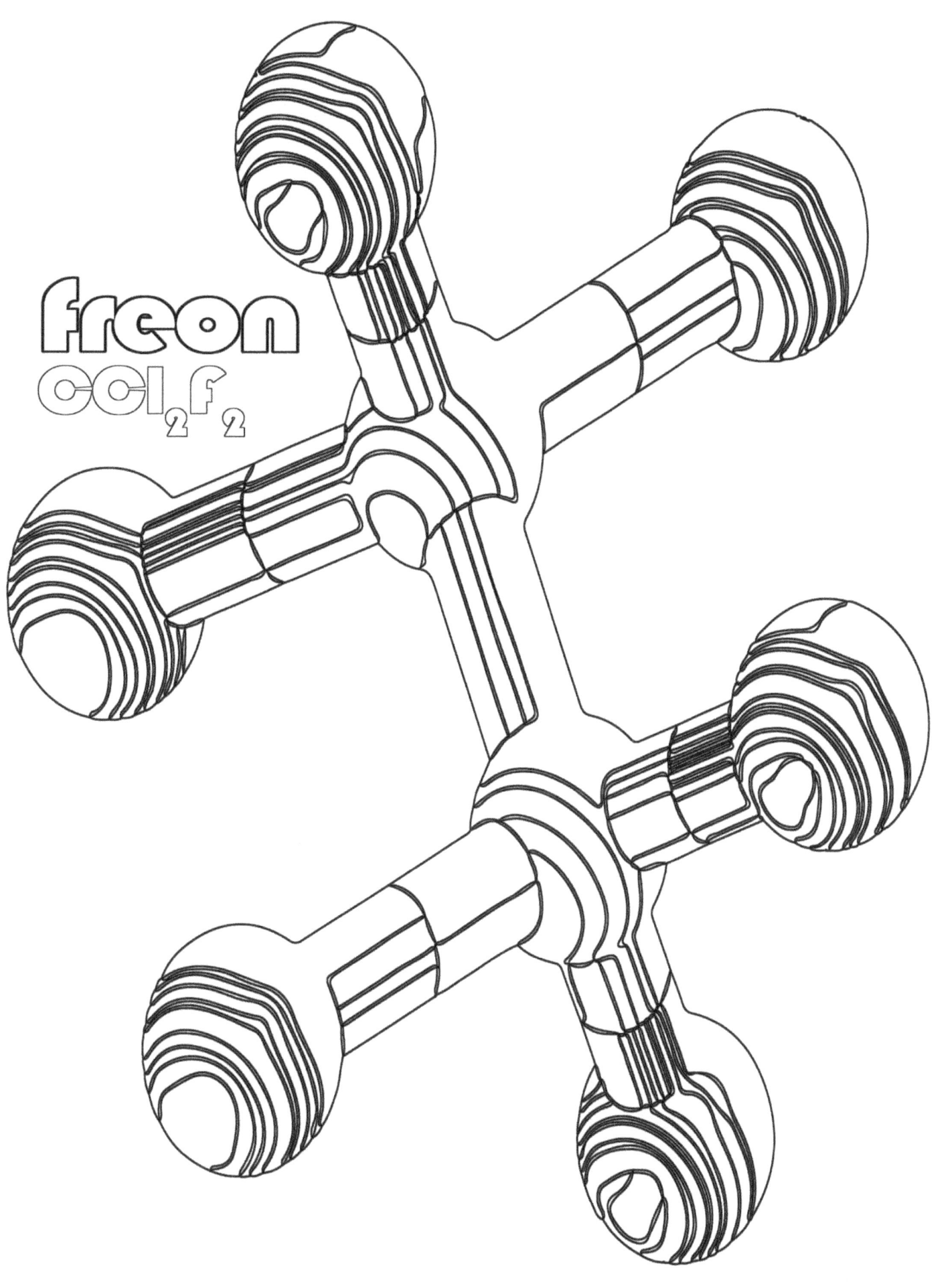

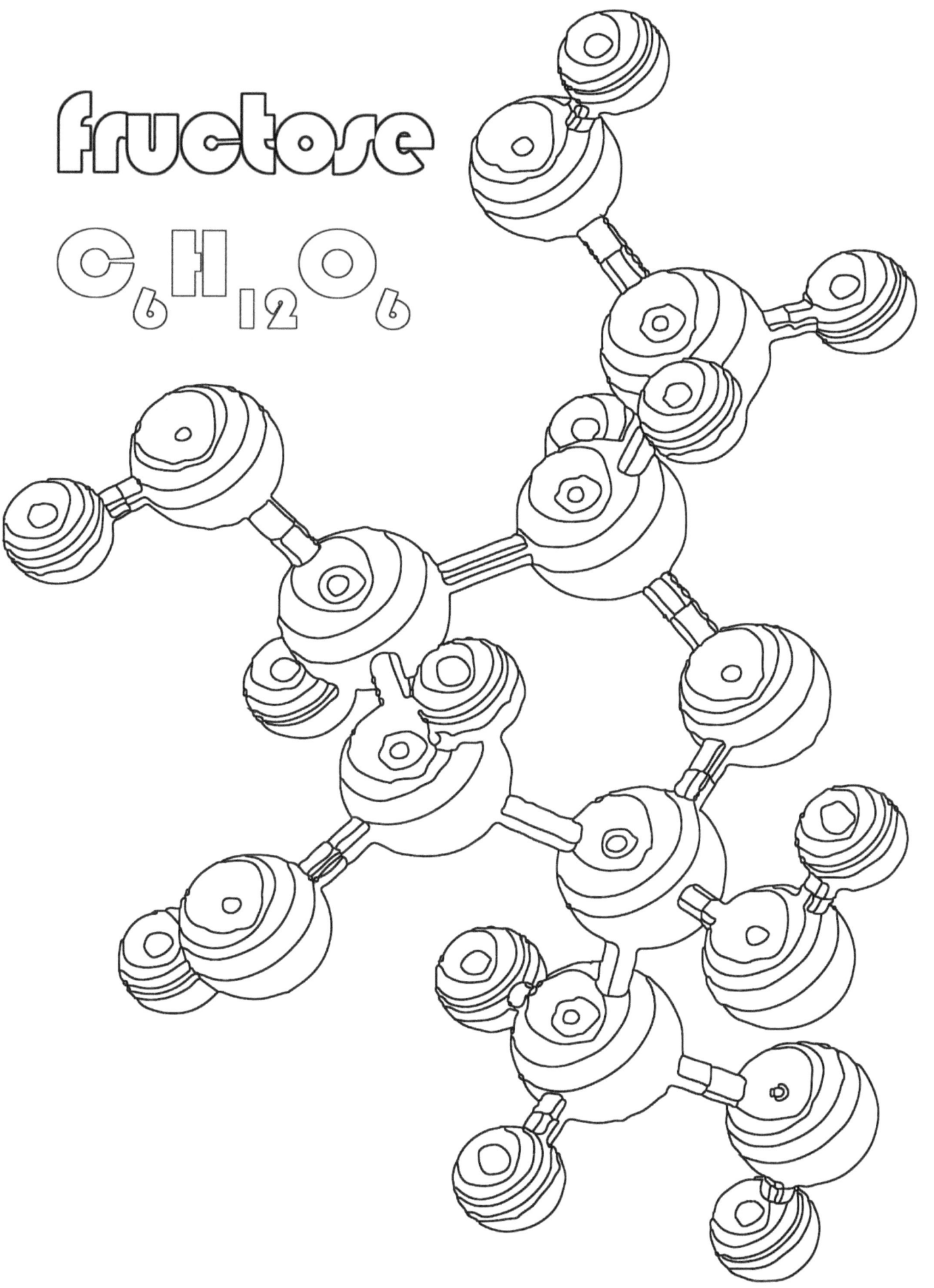

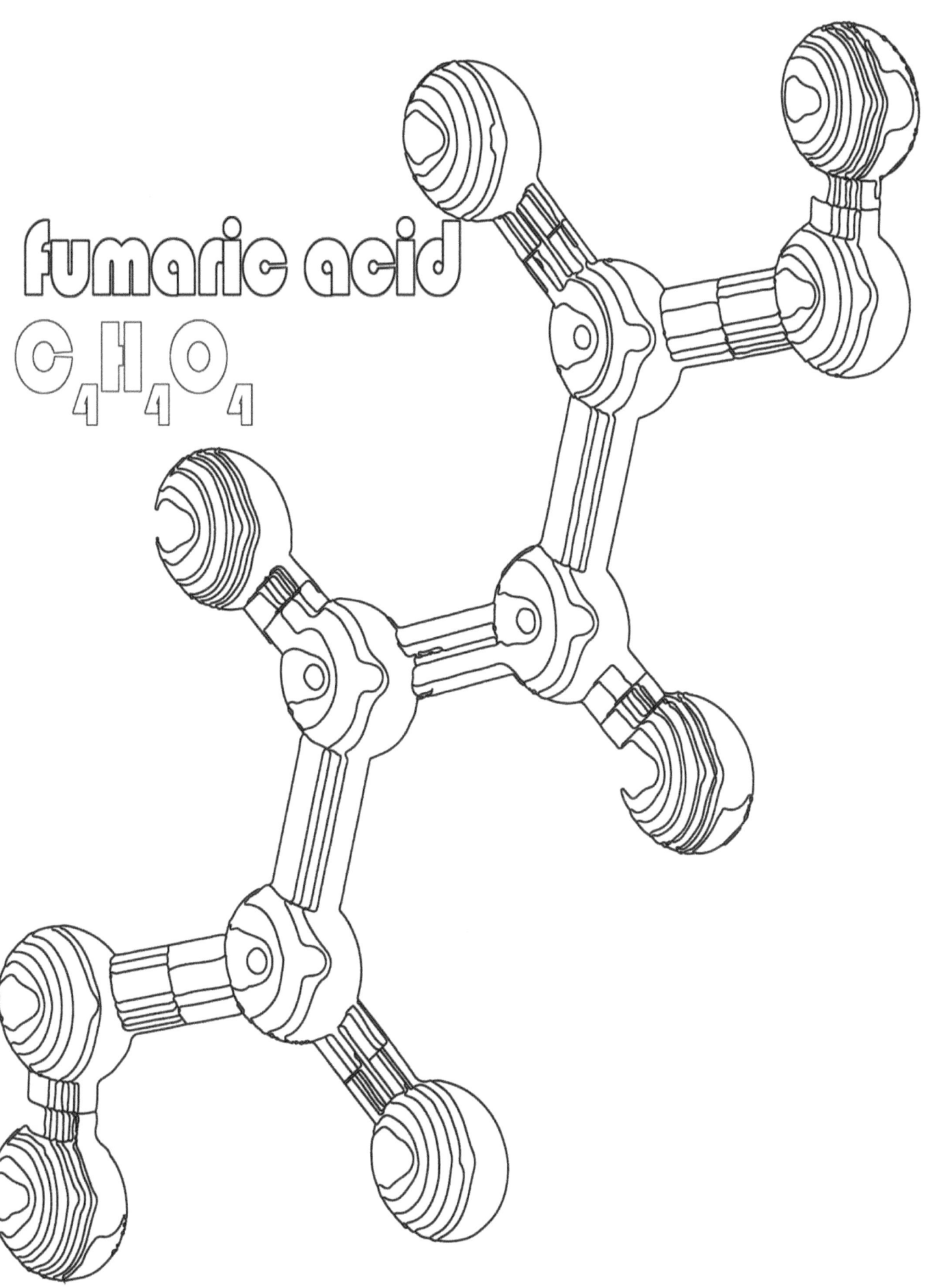

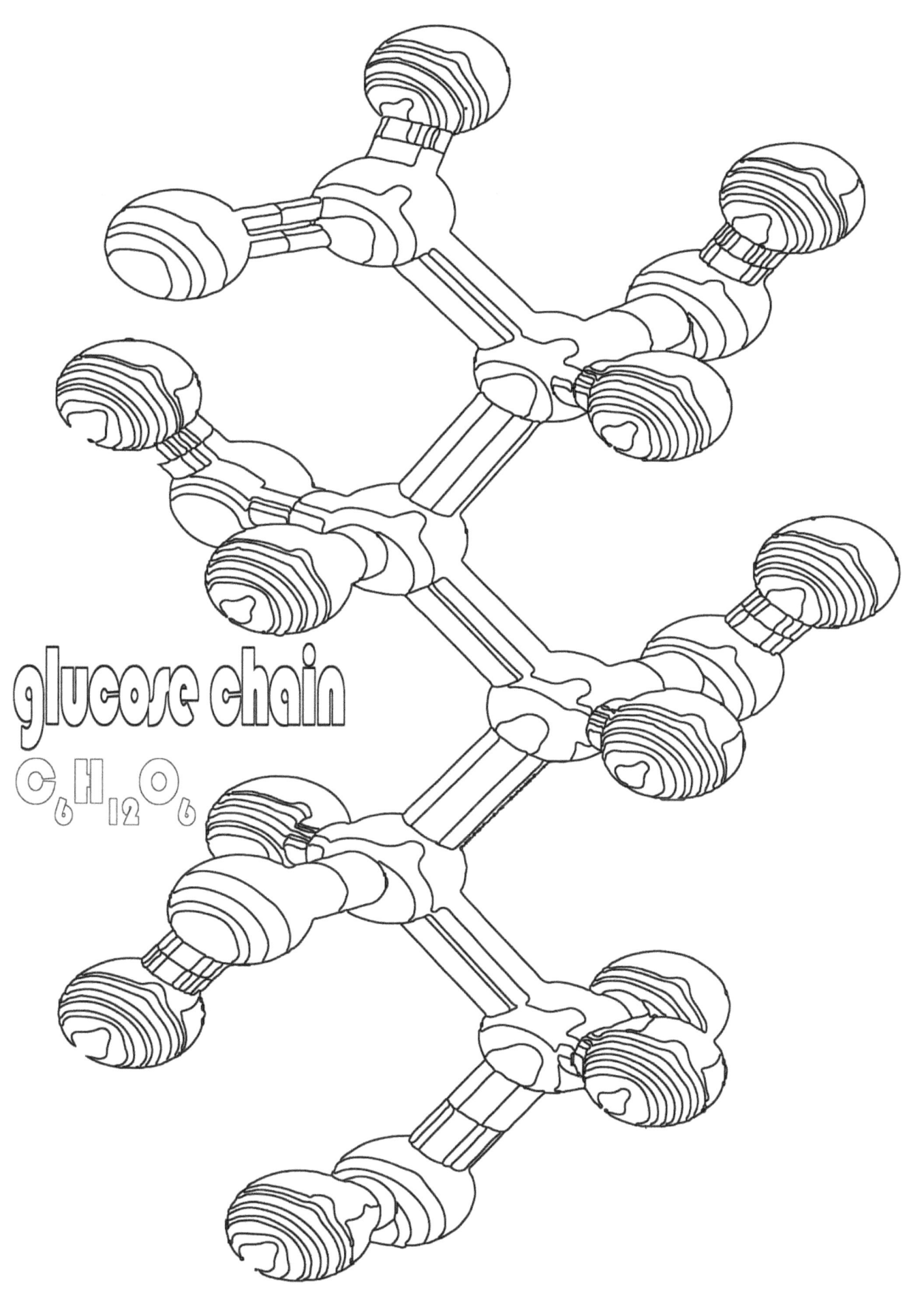

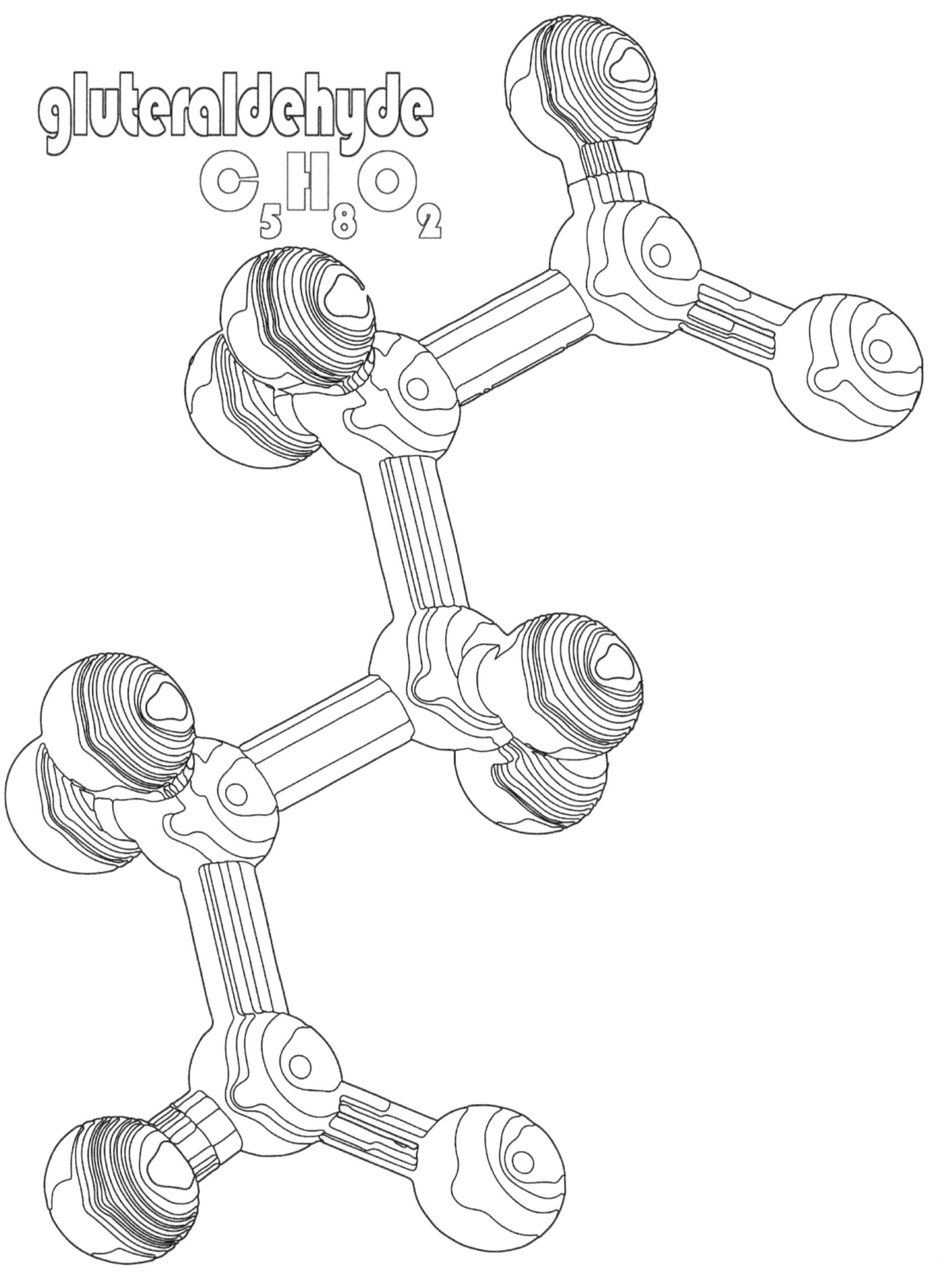

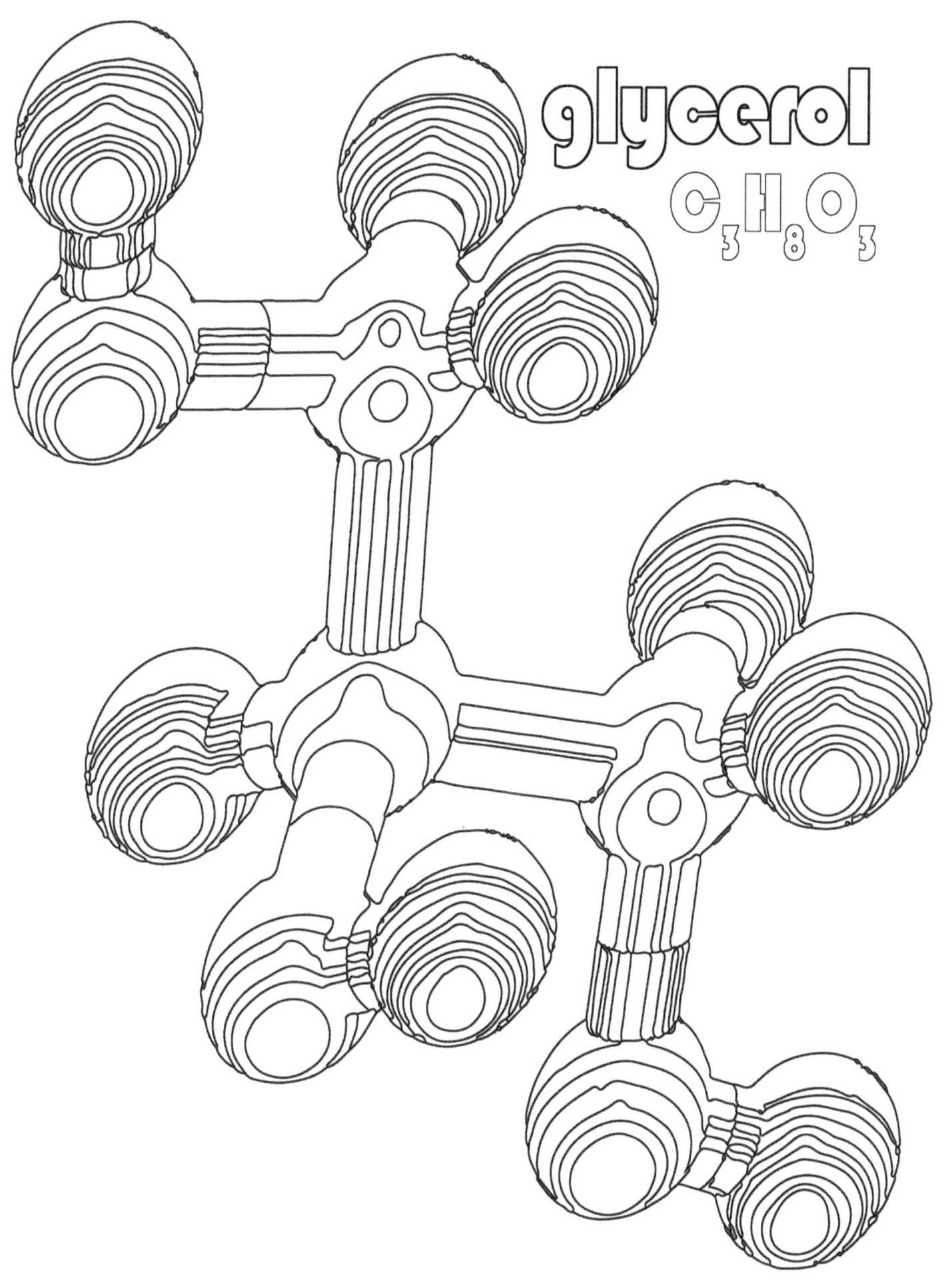

glycine condensation
$C_2H_5NO_2$

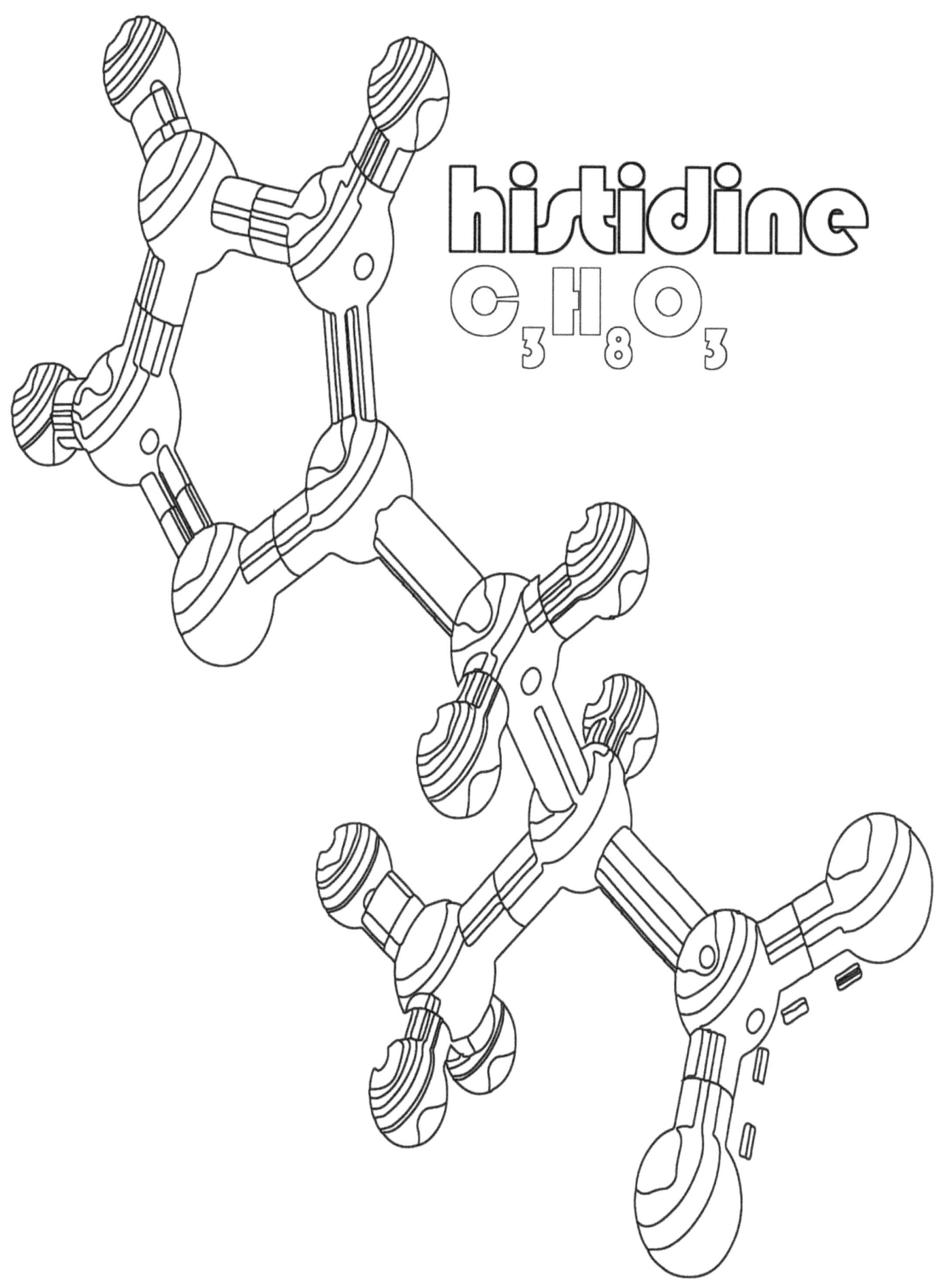

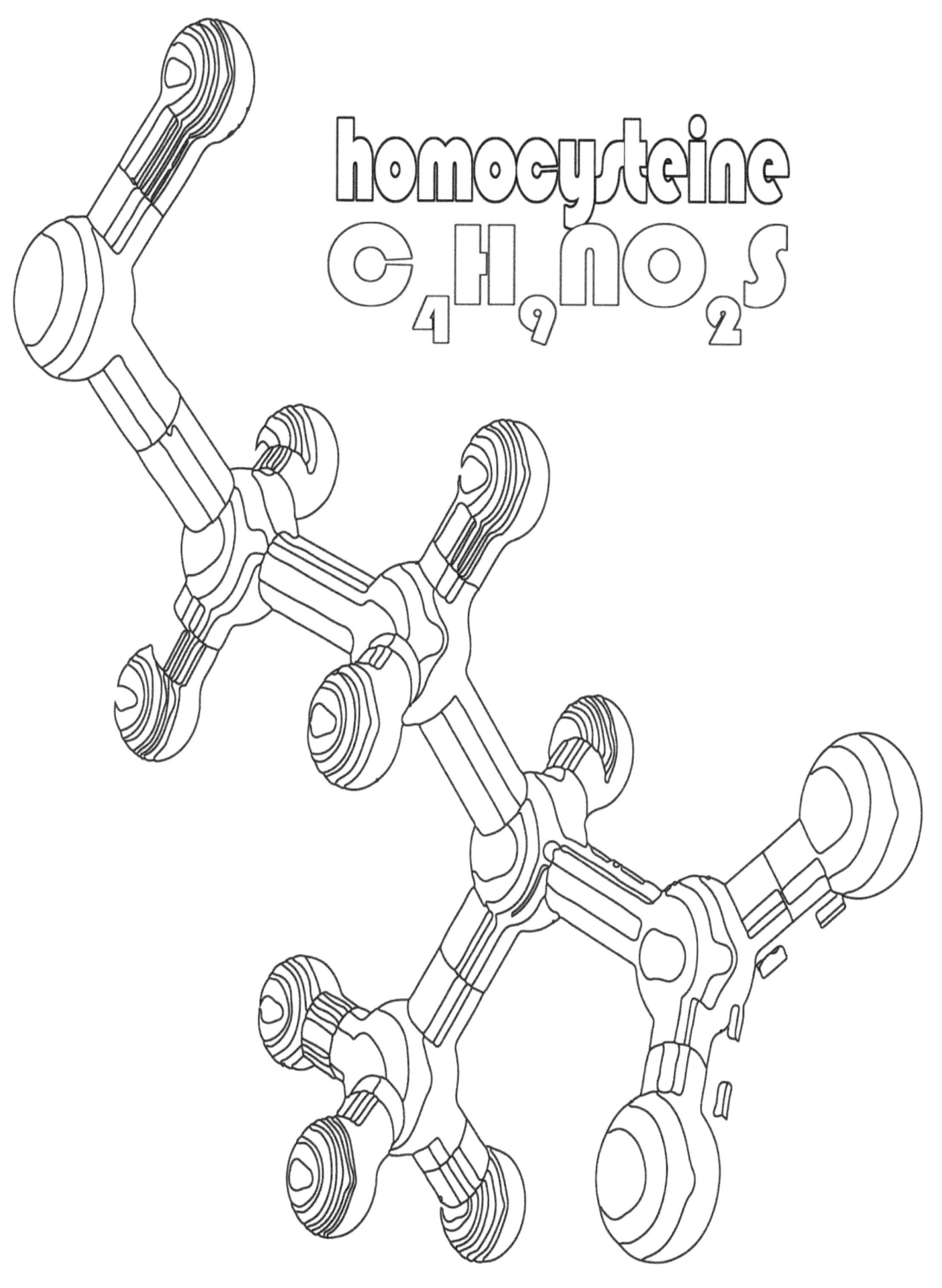

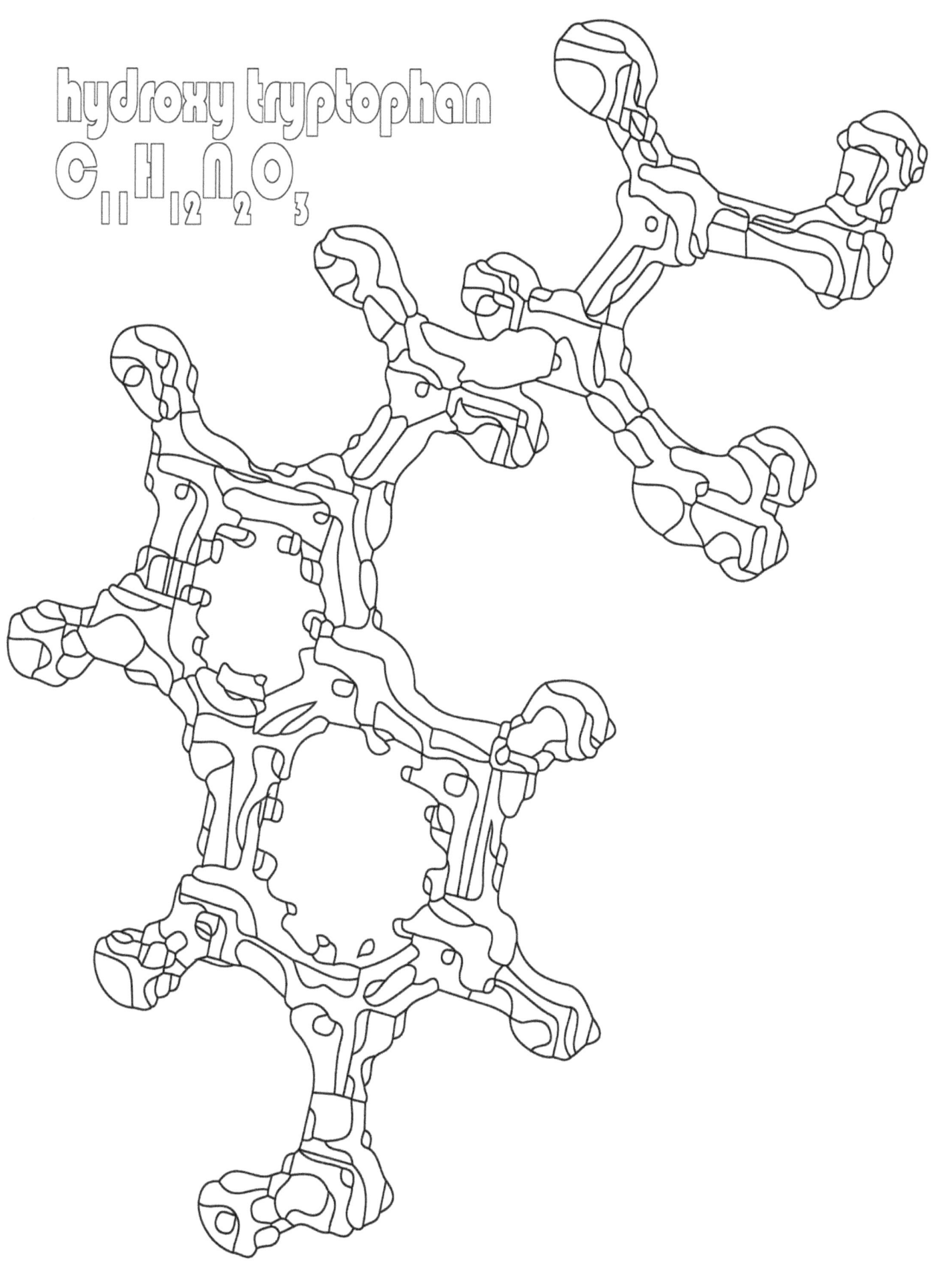

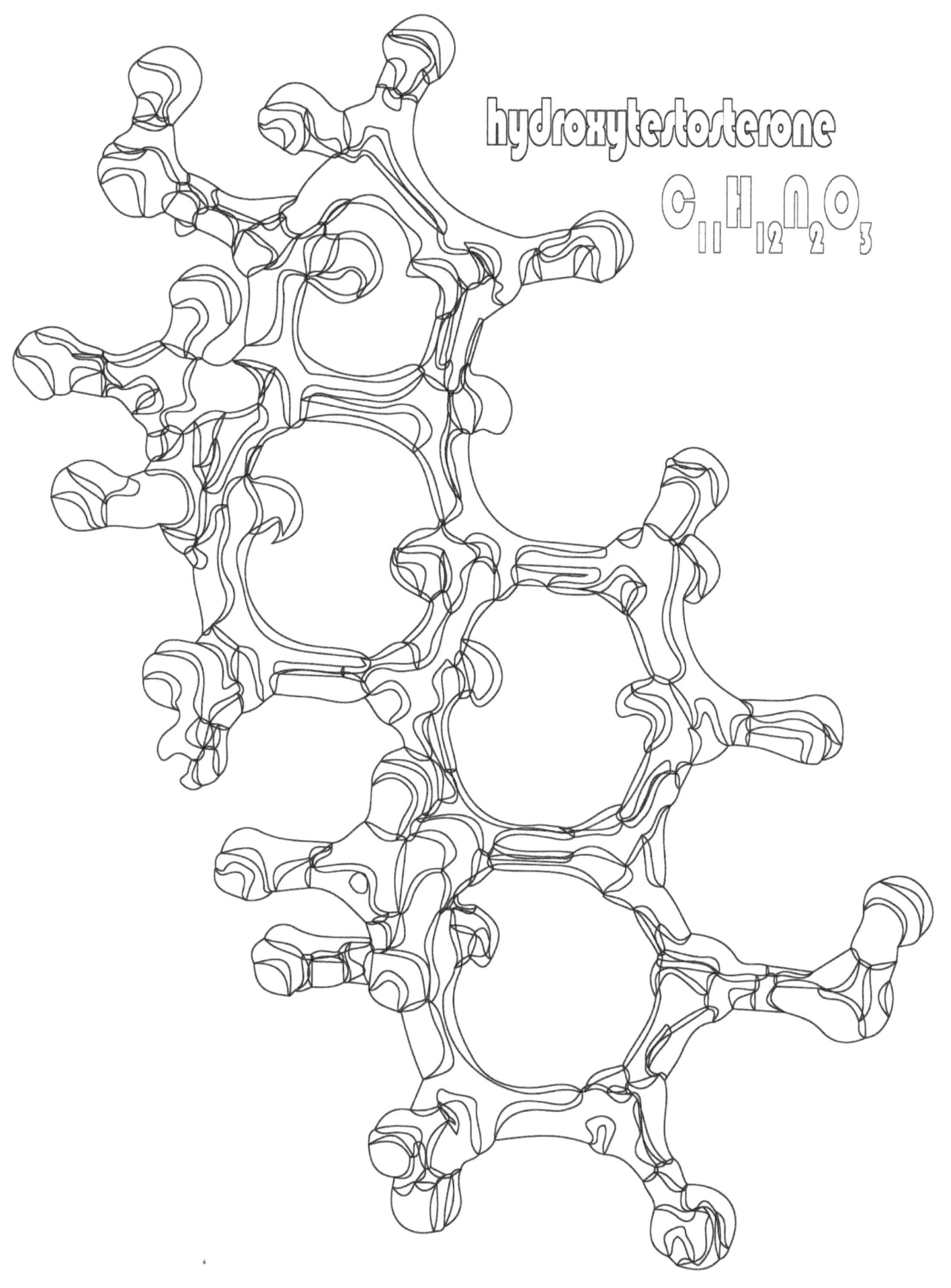

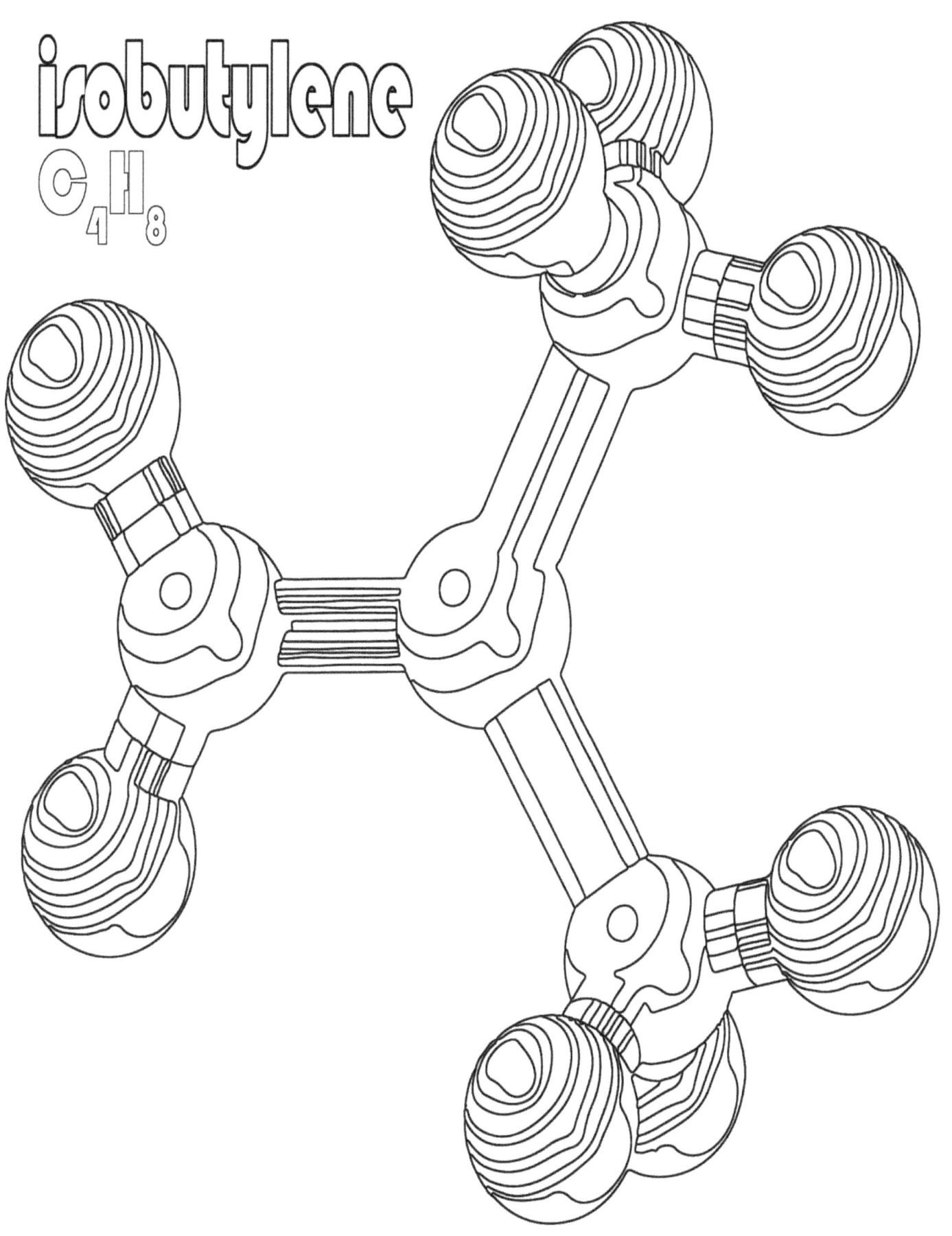

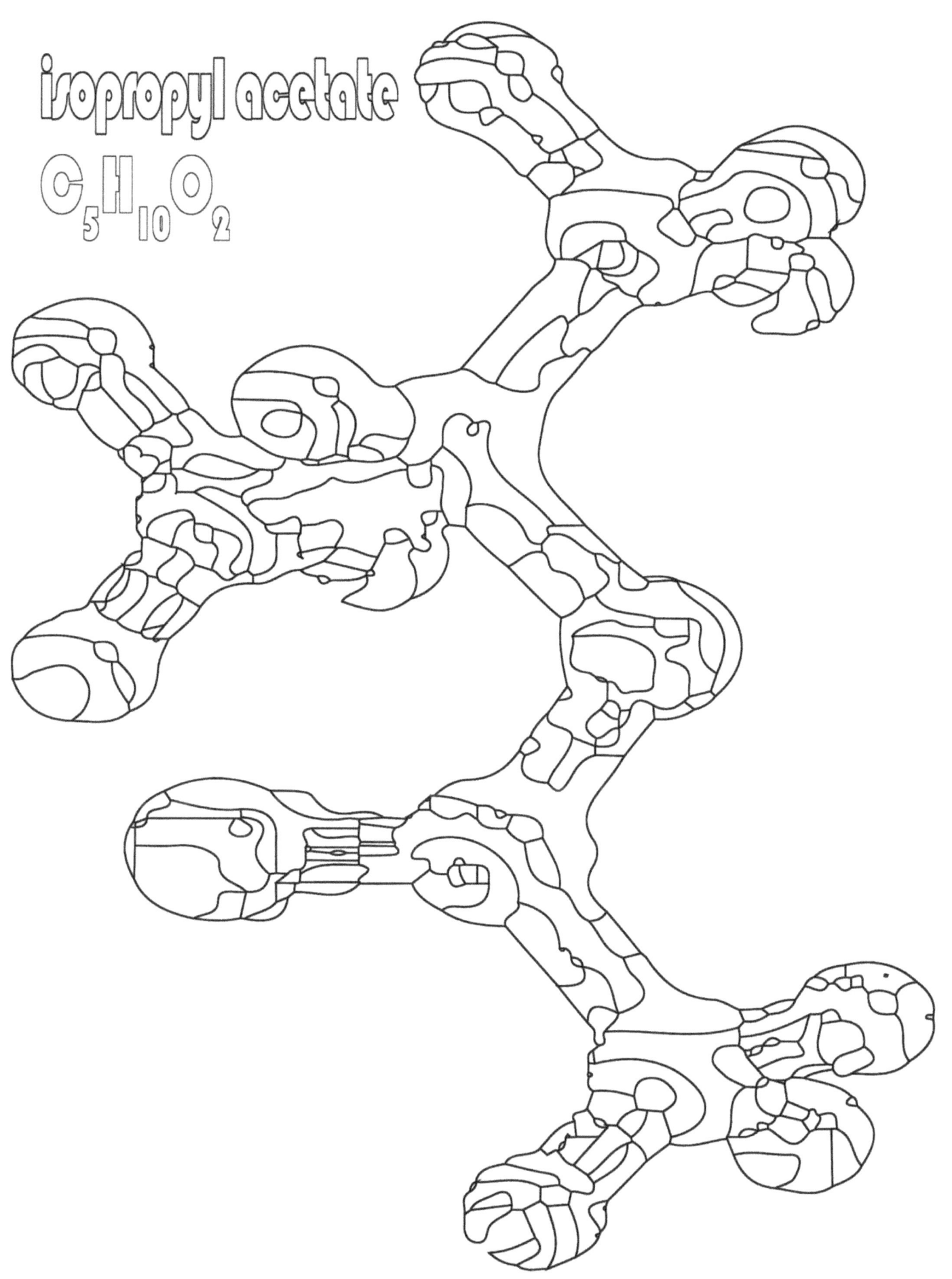

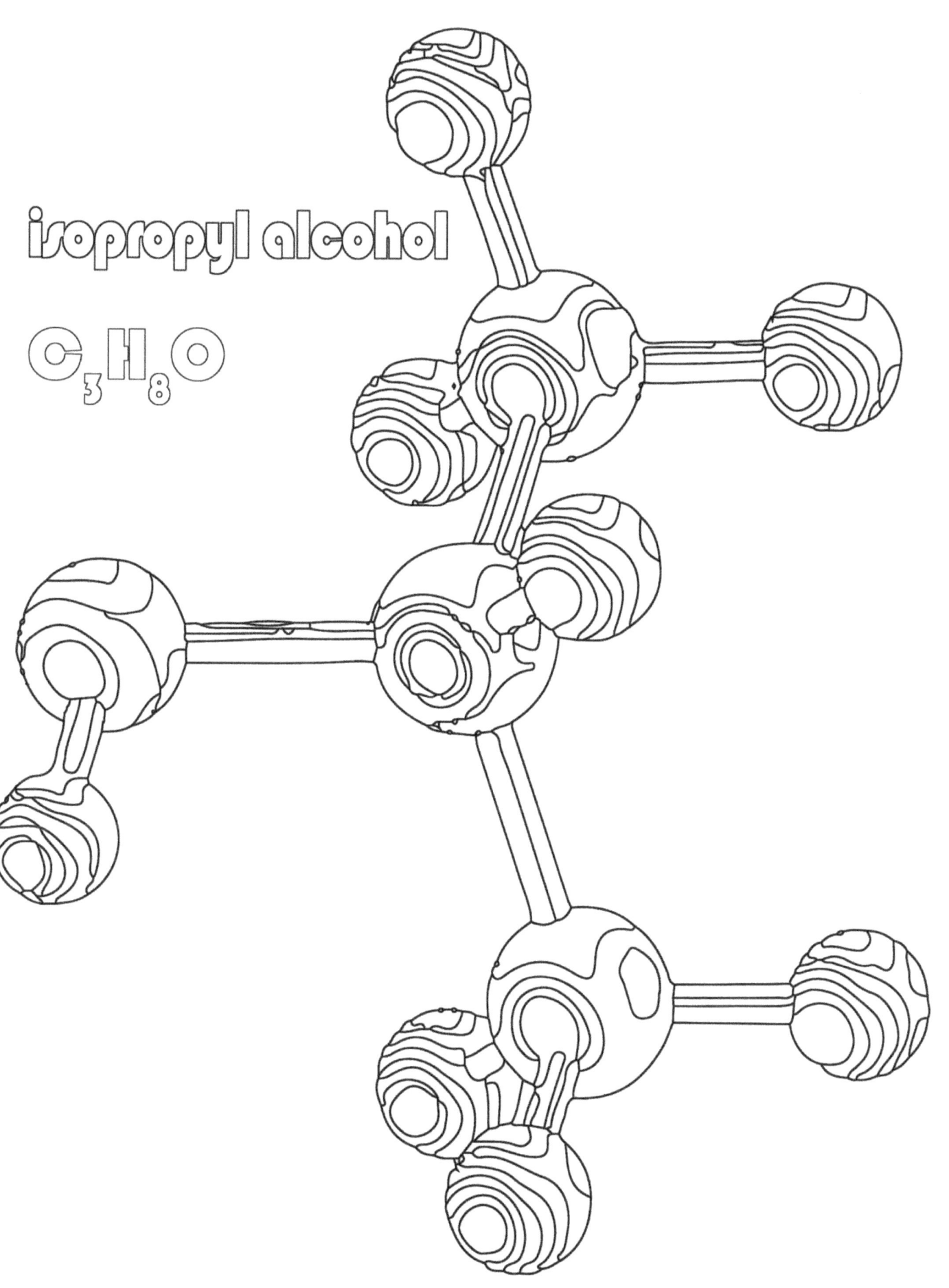

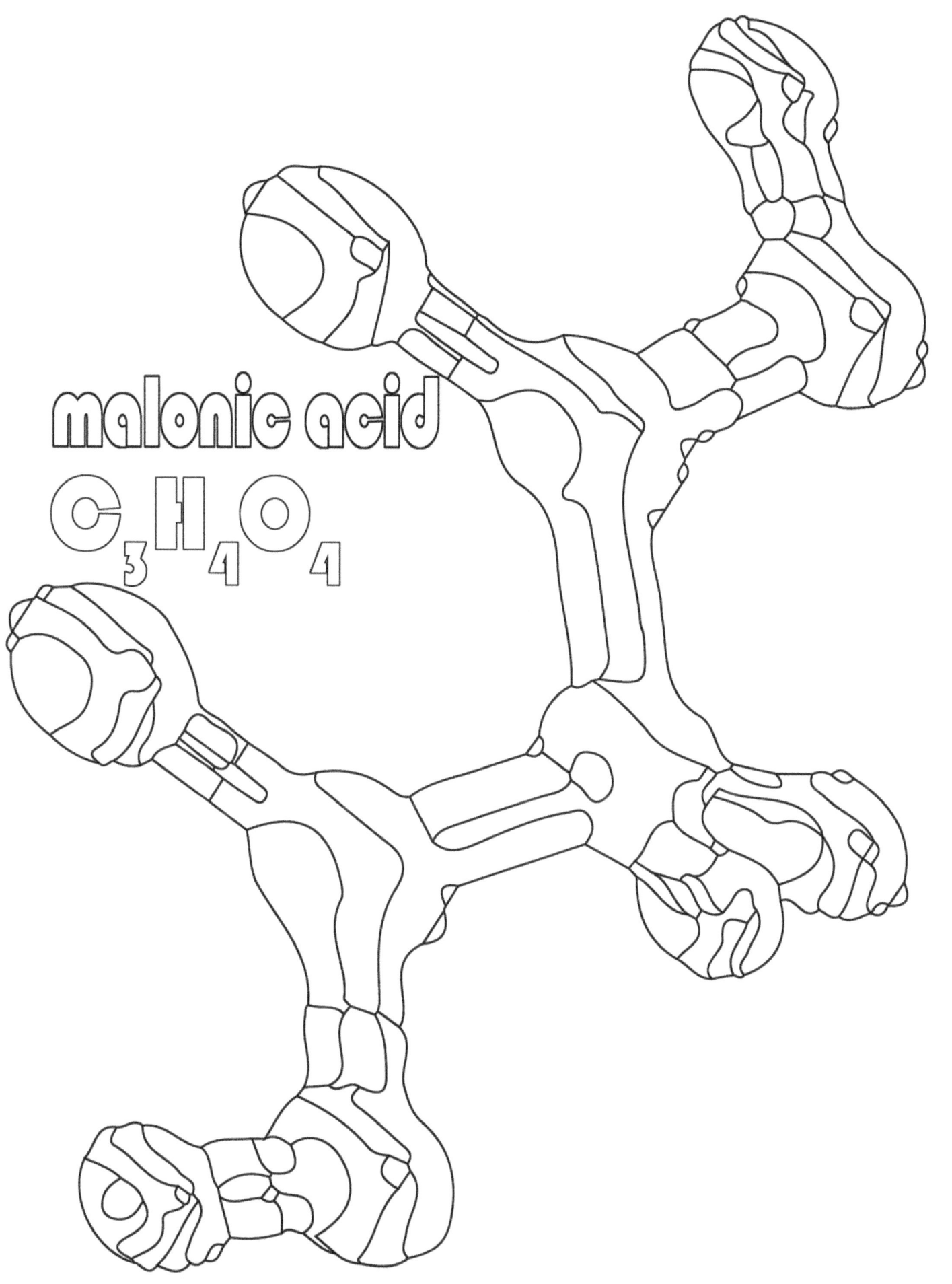

mesaconic acid
C$_5$H$_6$O$_4$

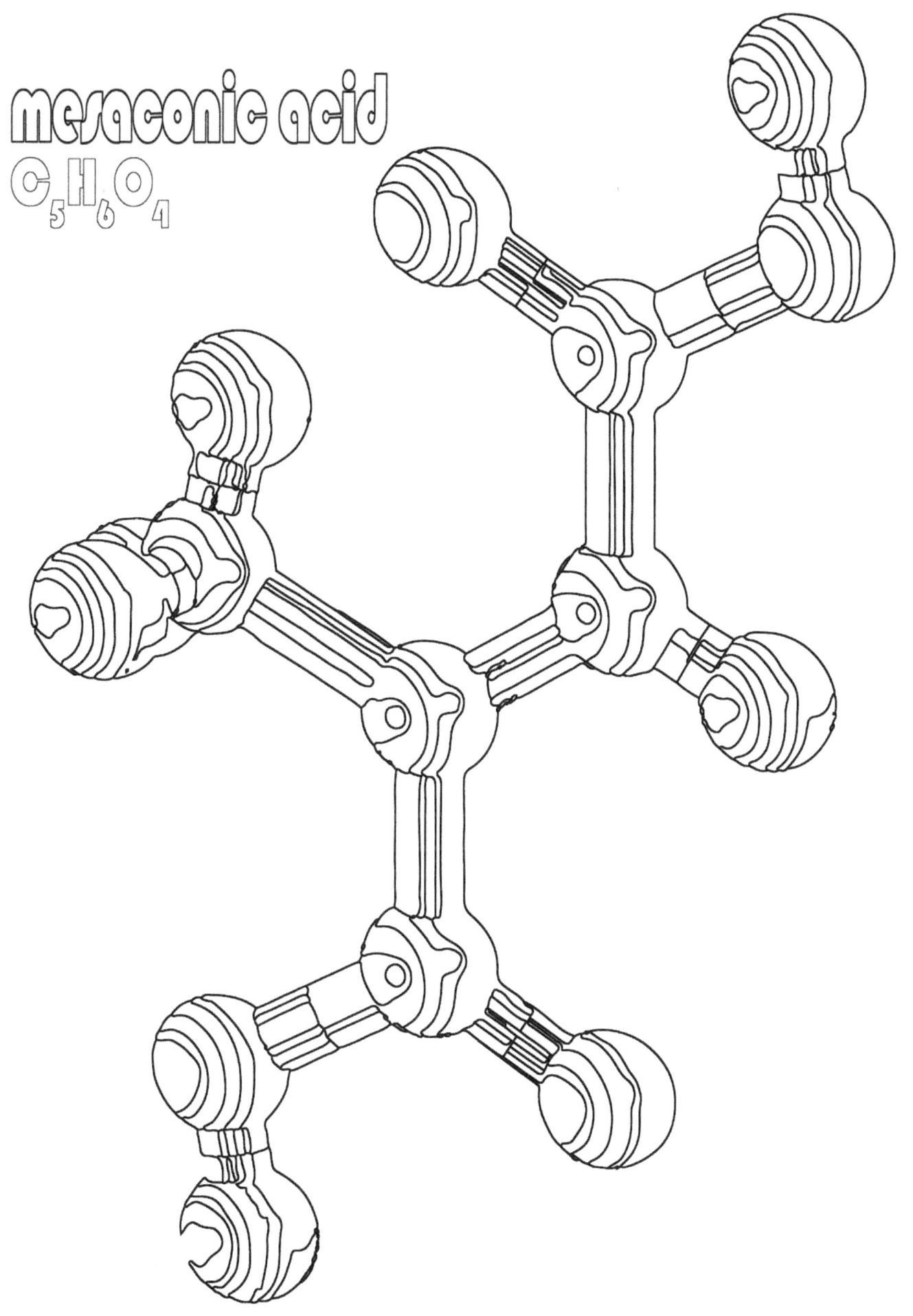

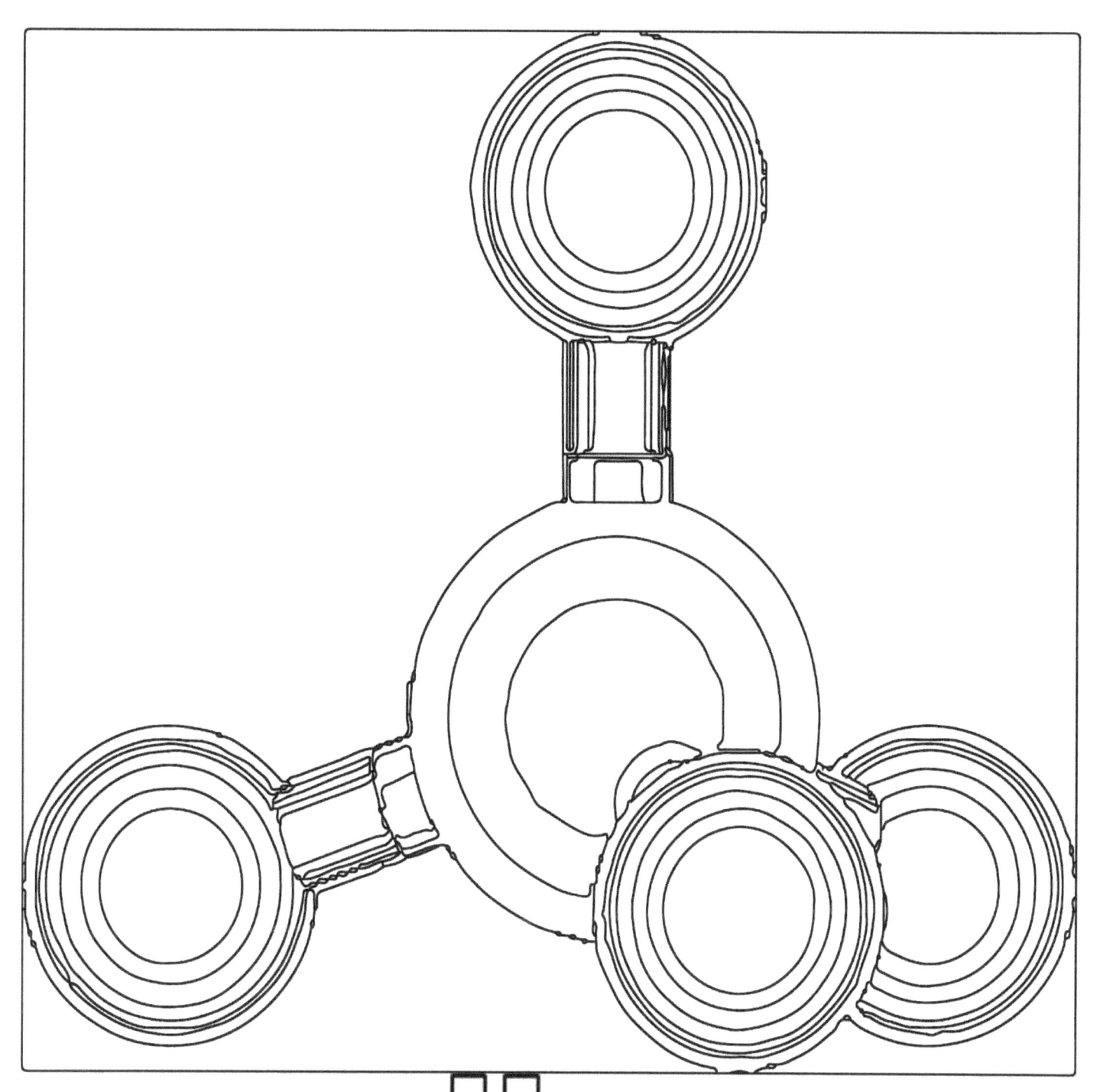

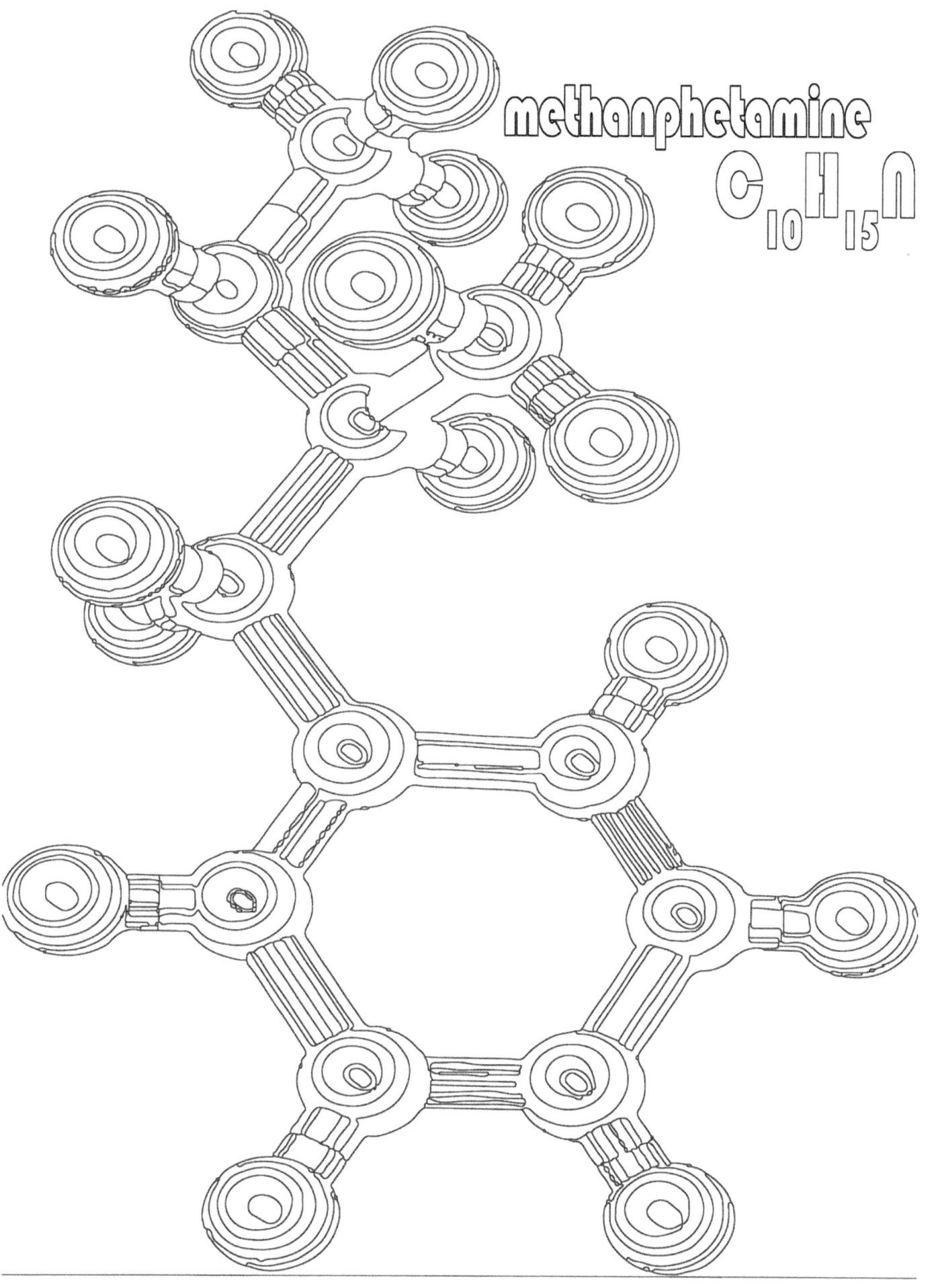

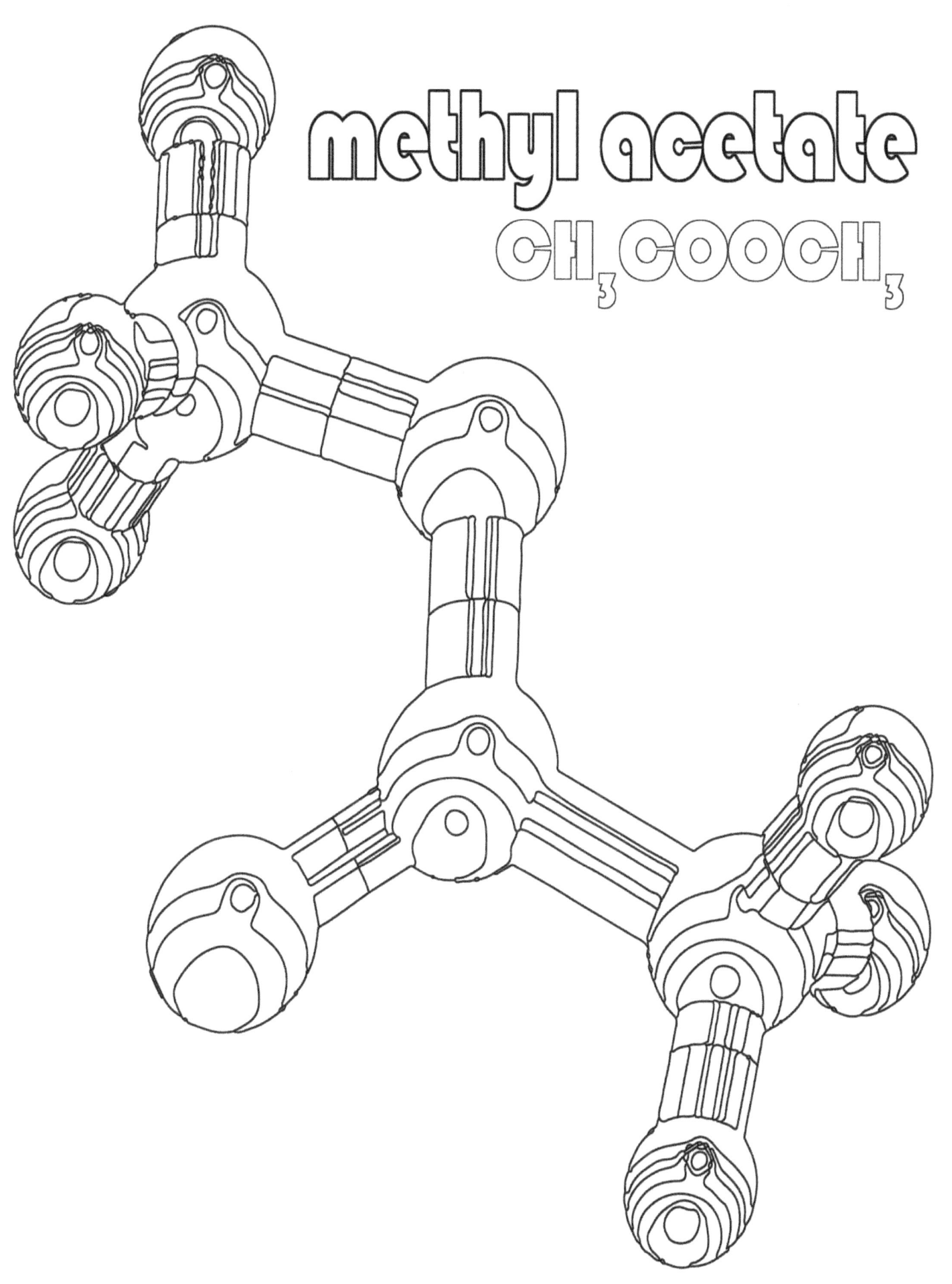

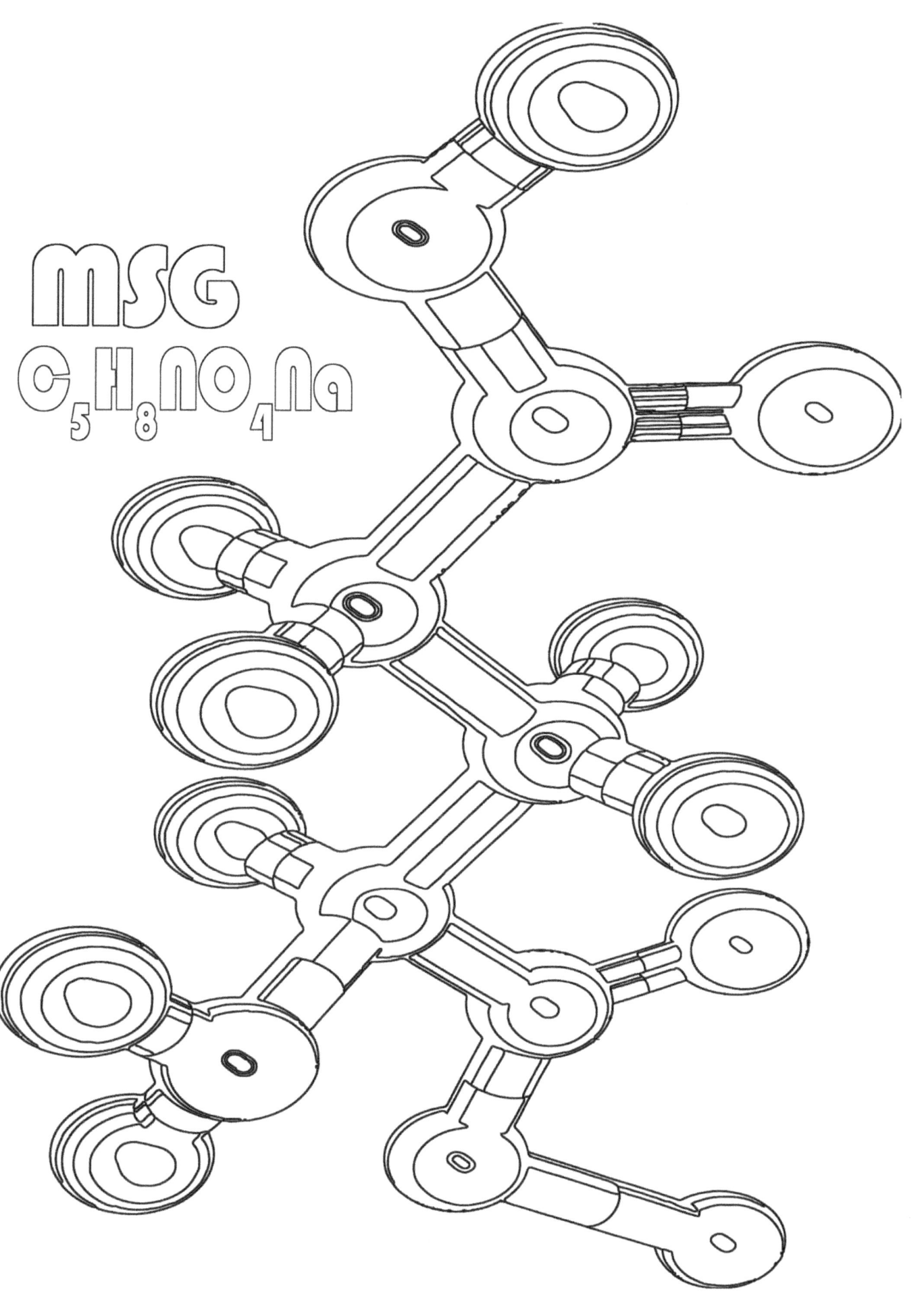

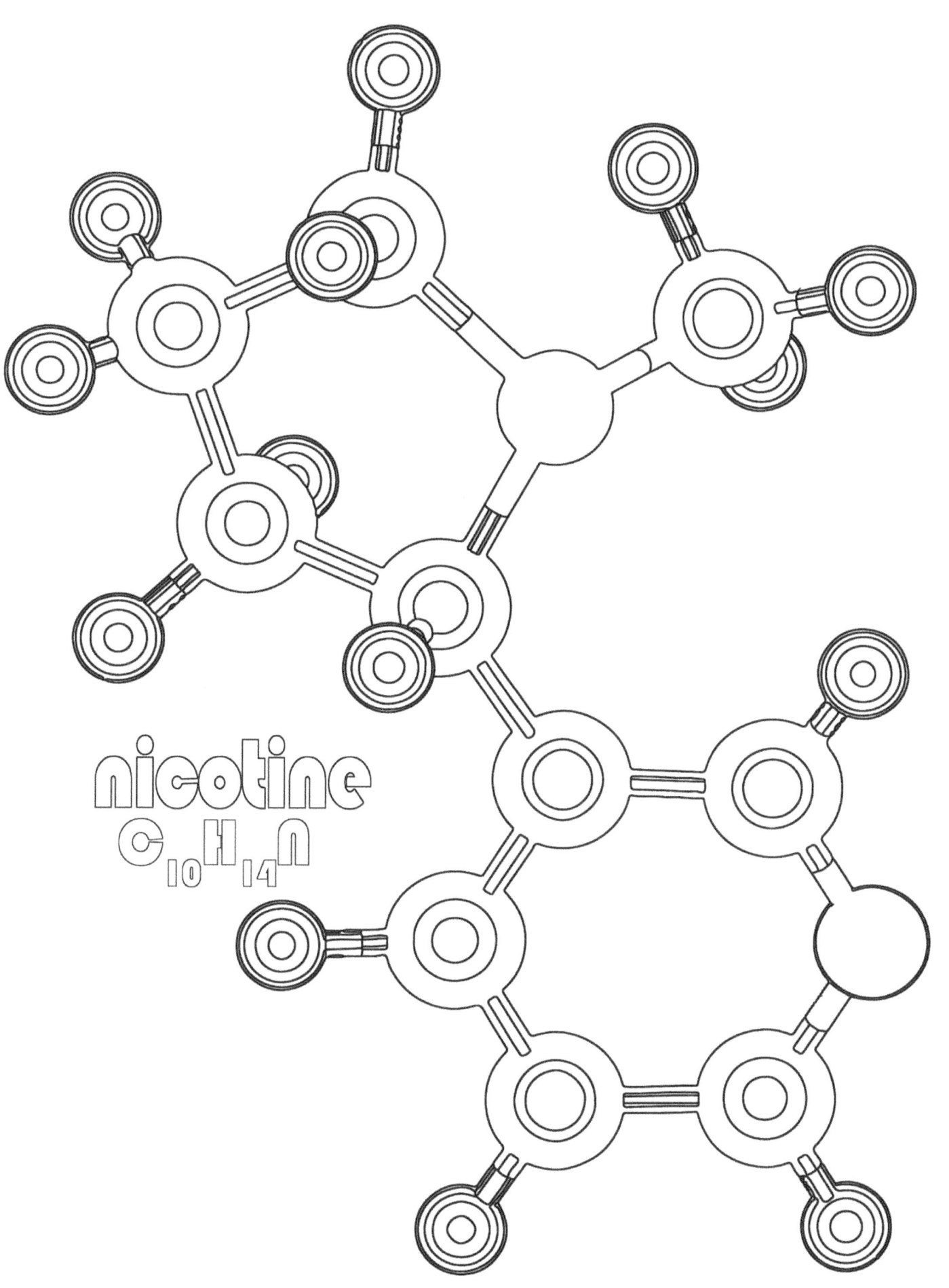

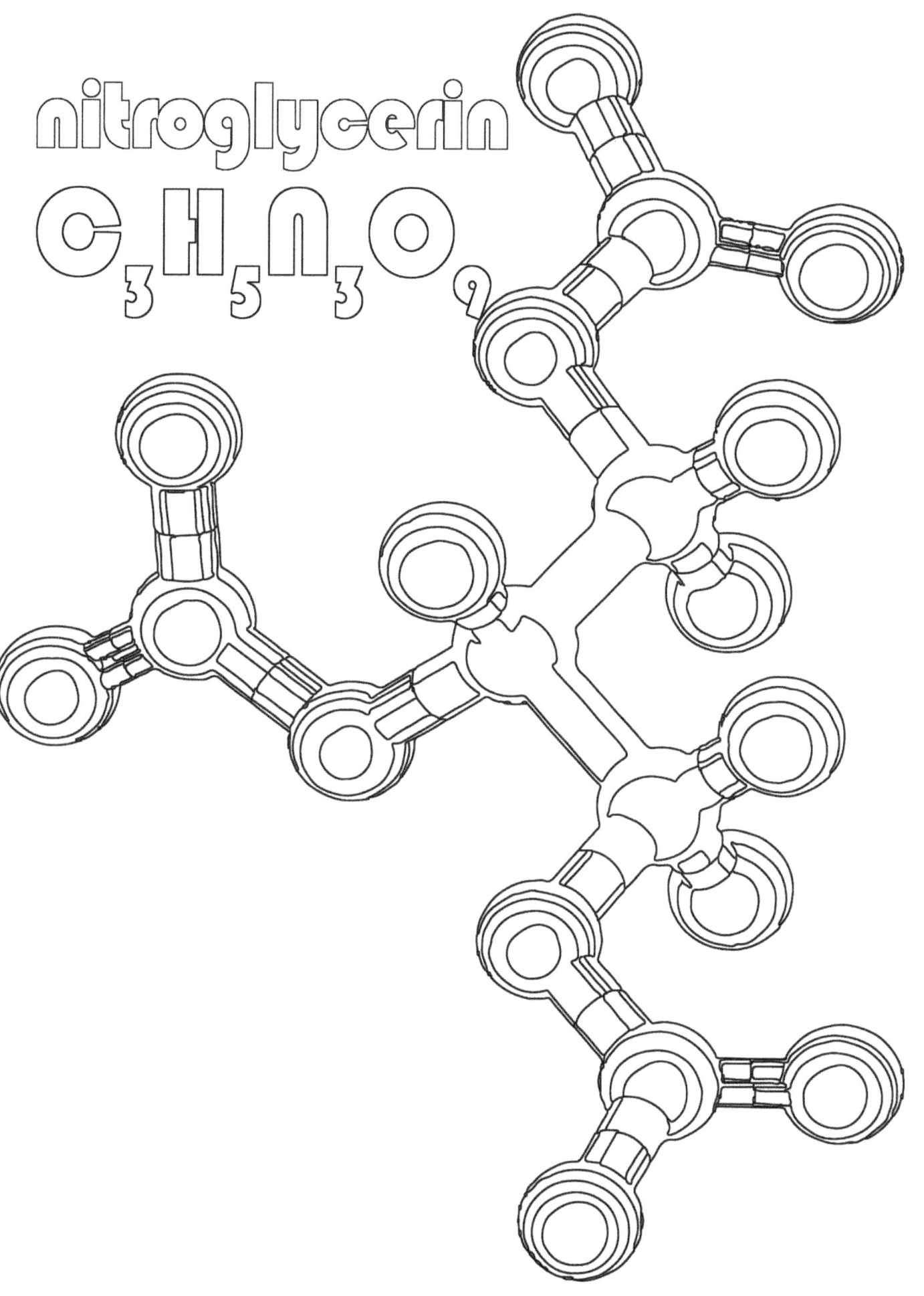

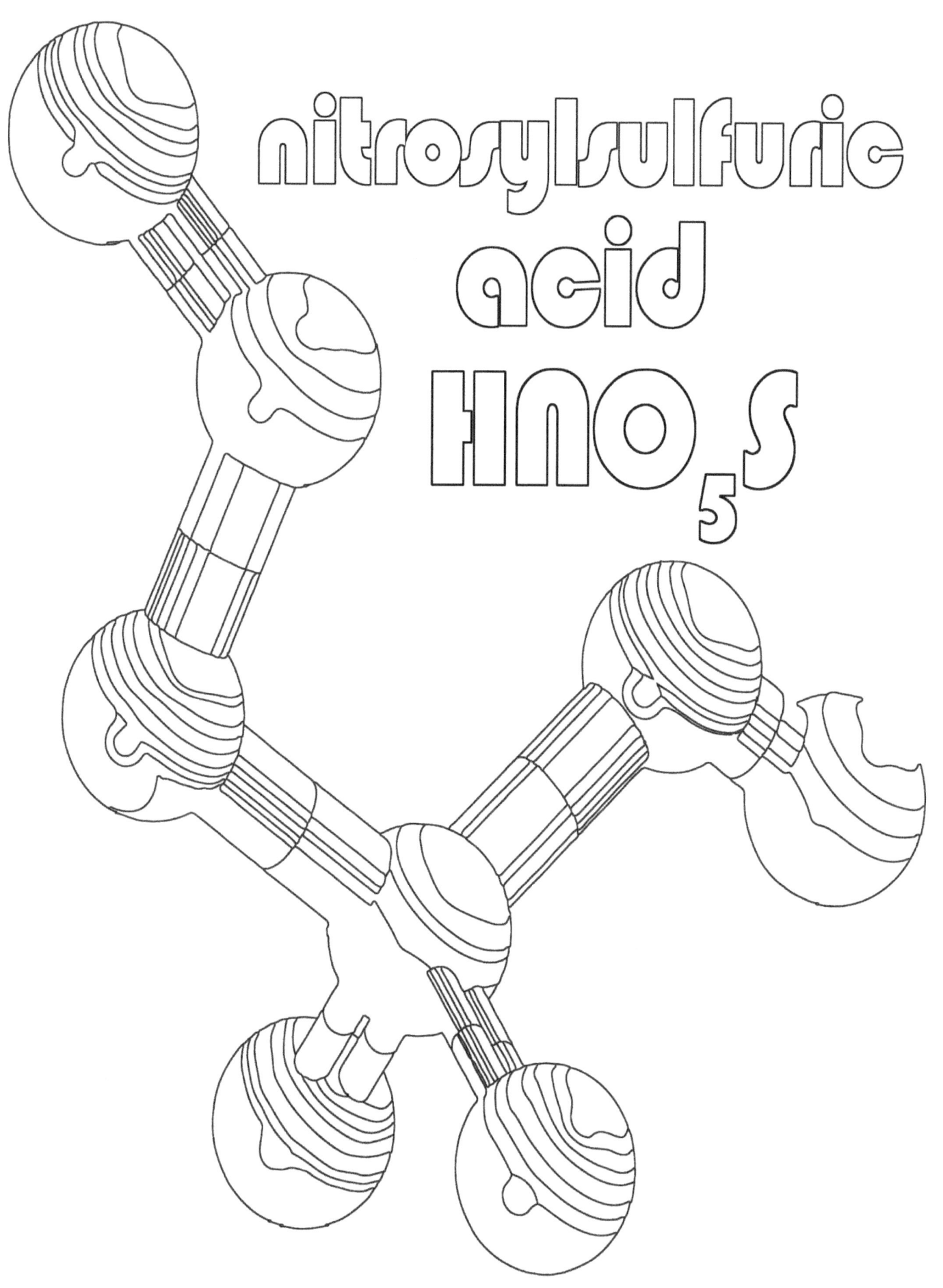

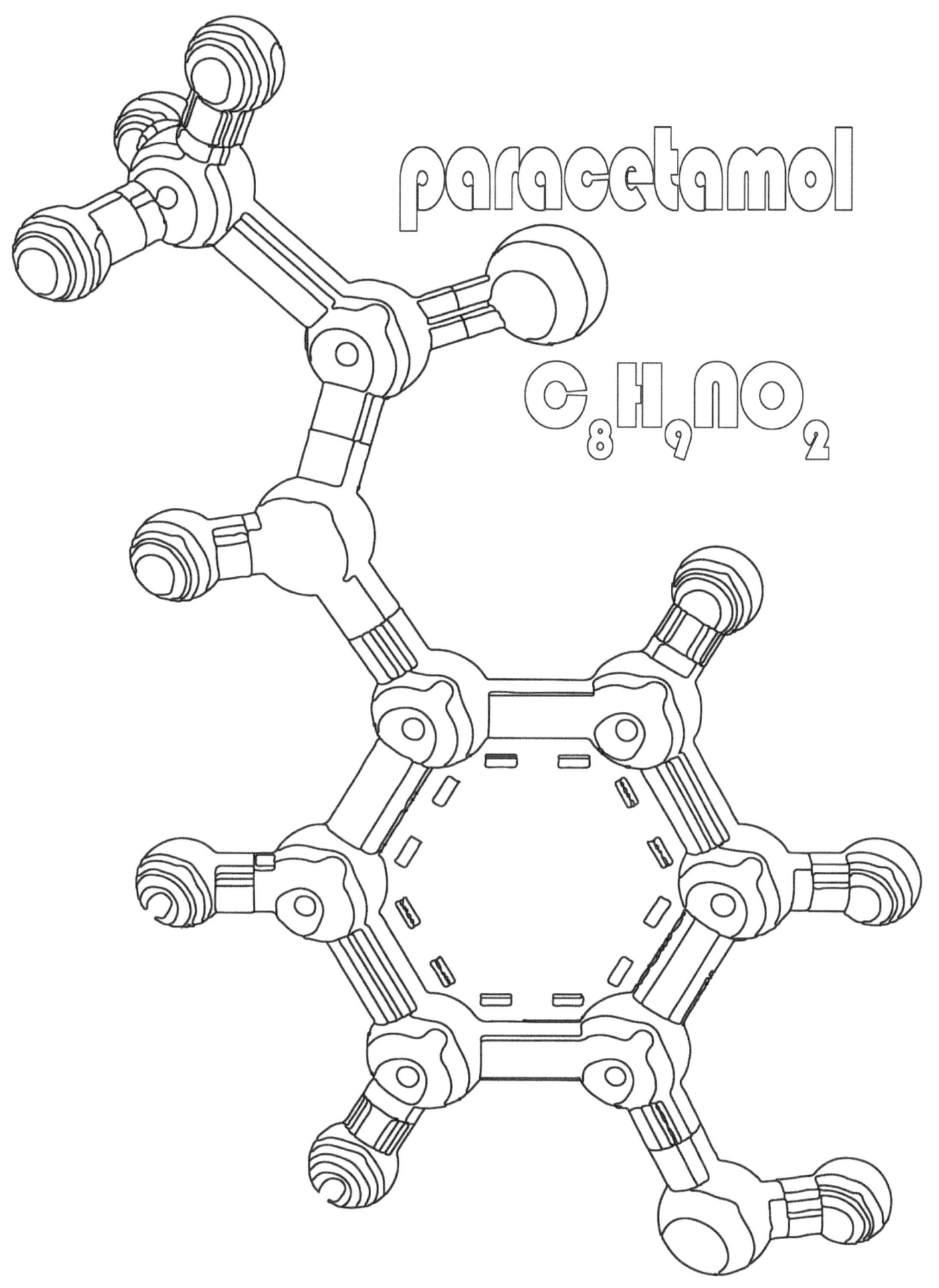

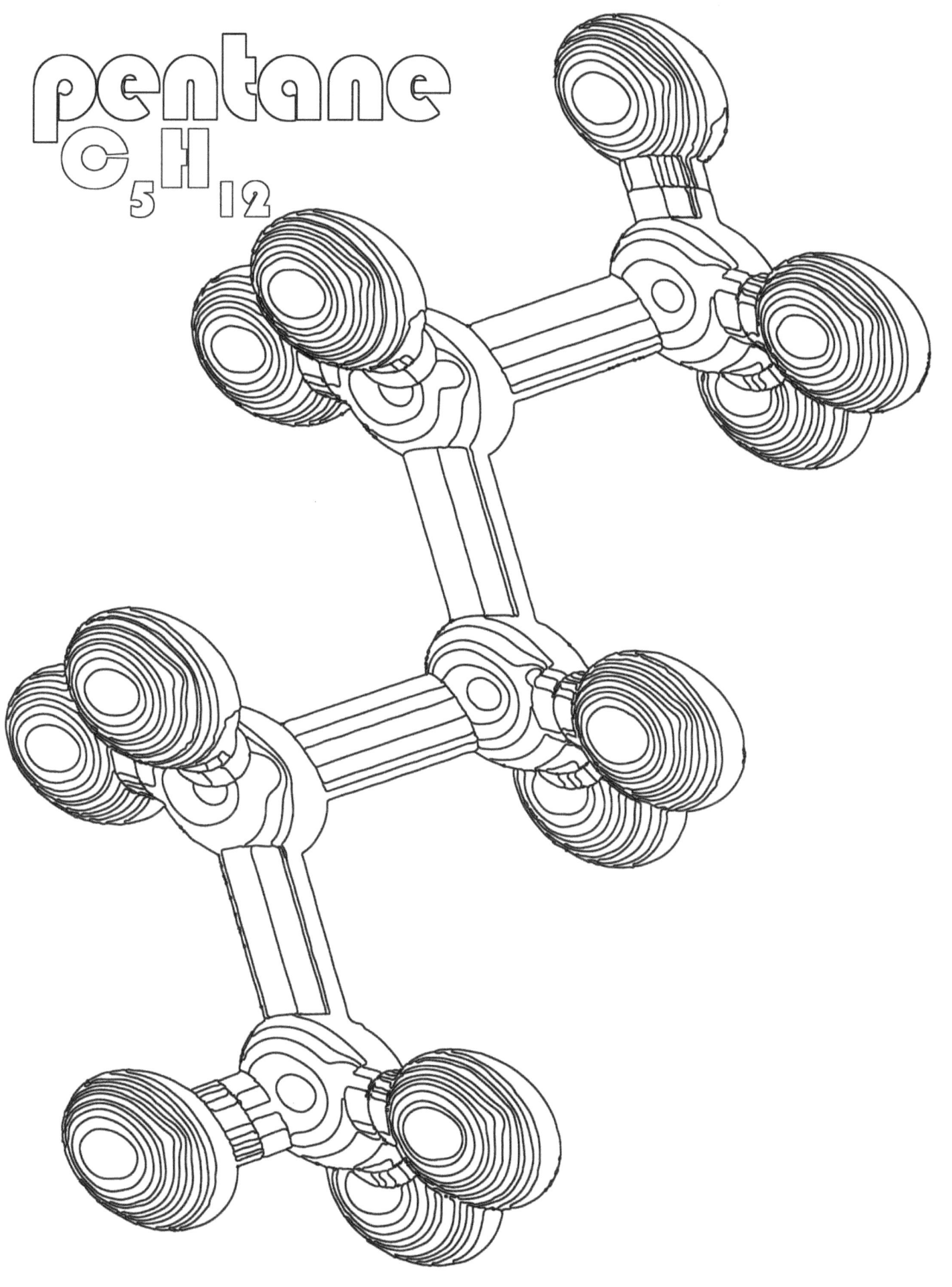

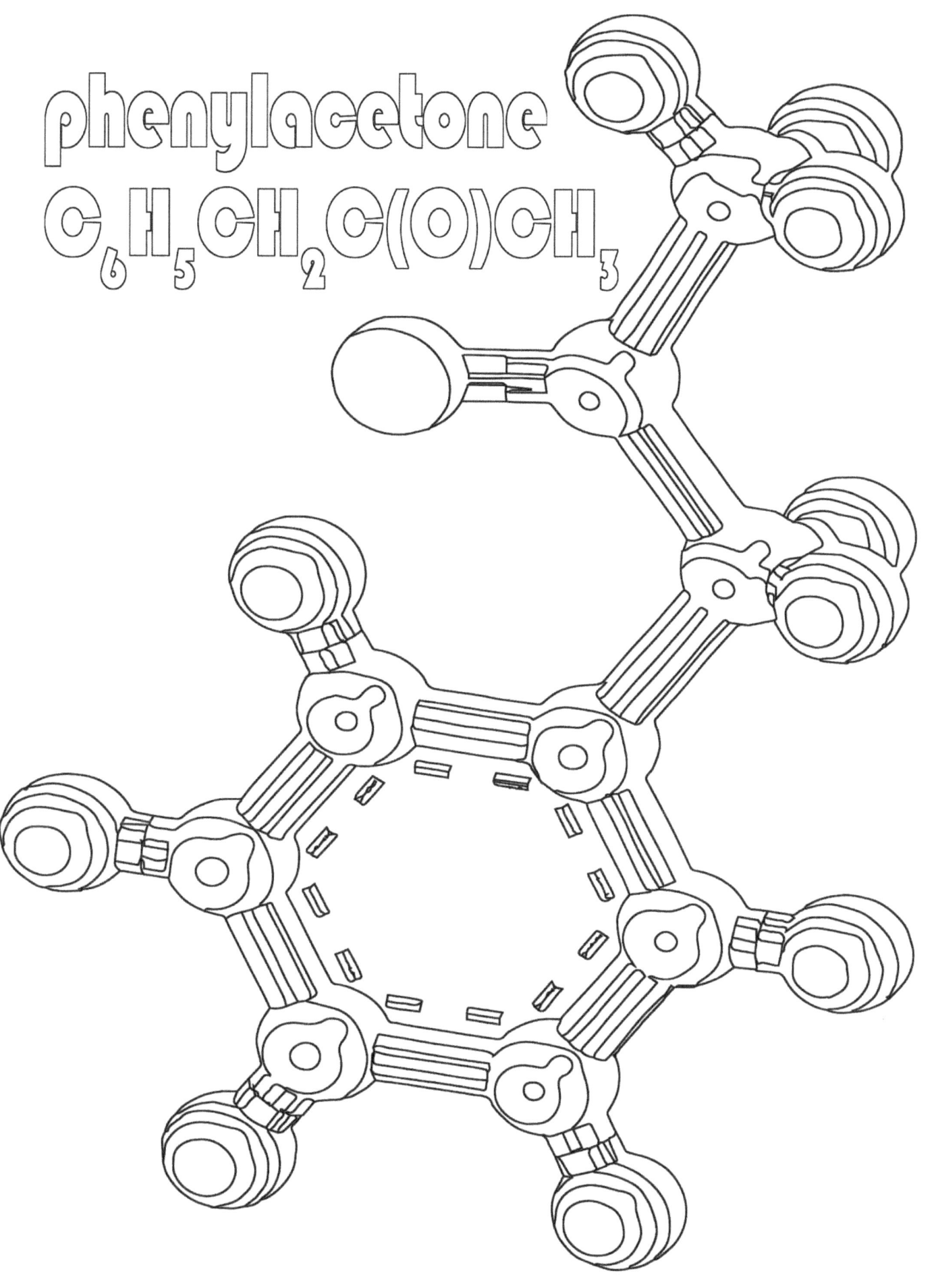

phenylacetone
$C_6H_5CH_2C(O)CH_3$

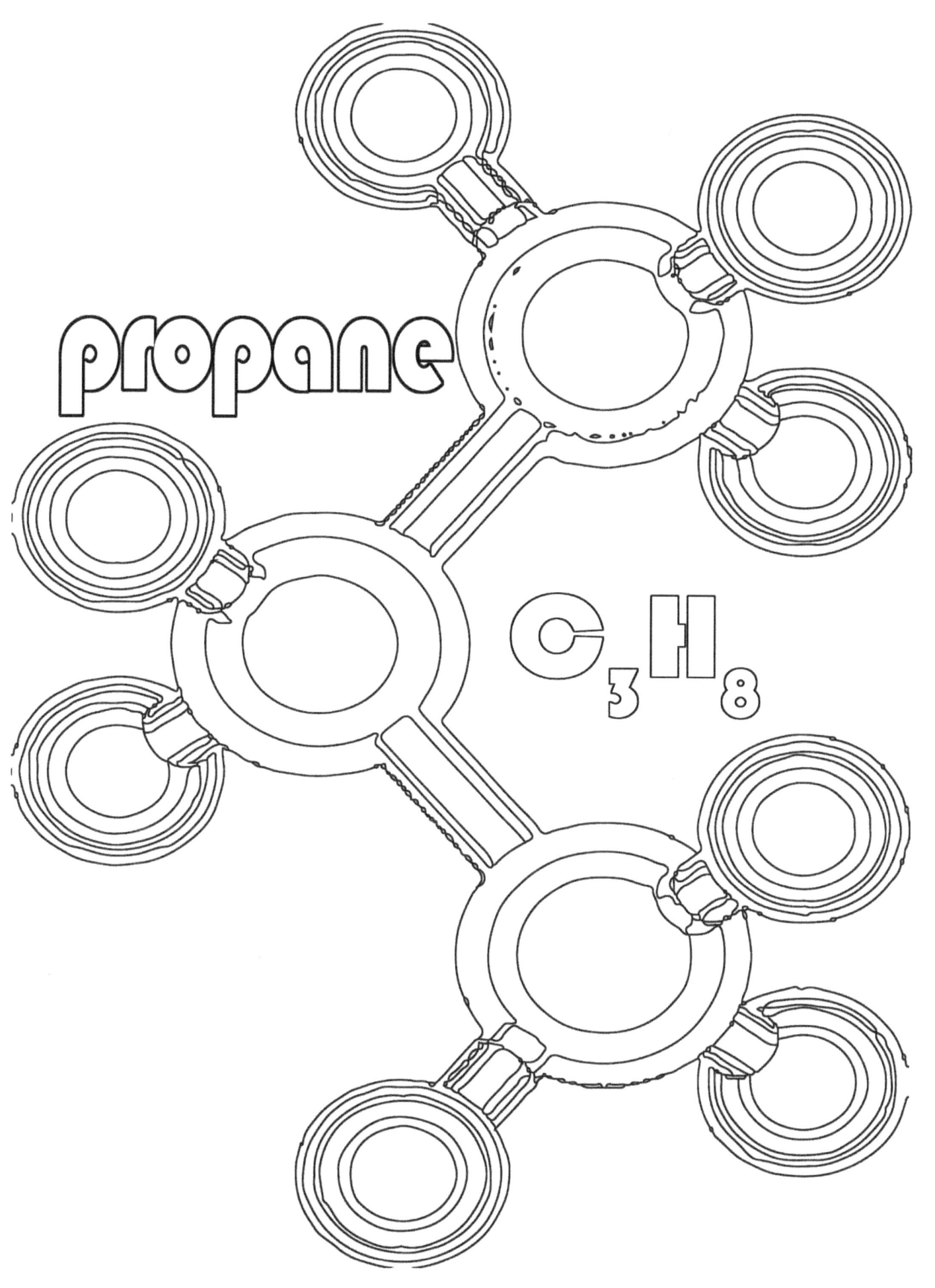

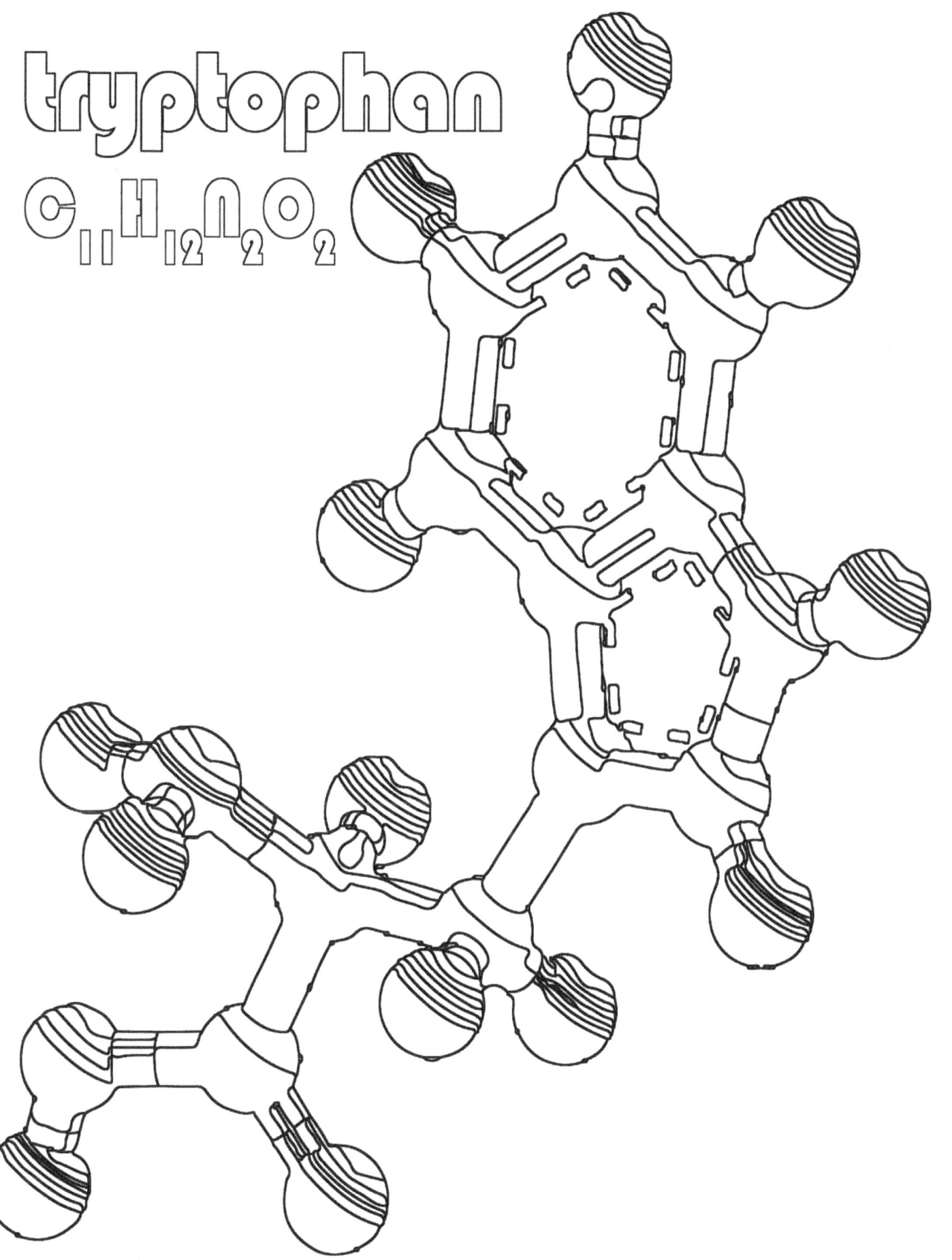

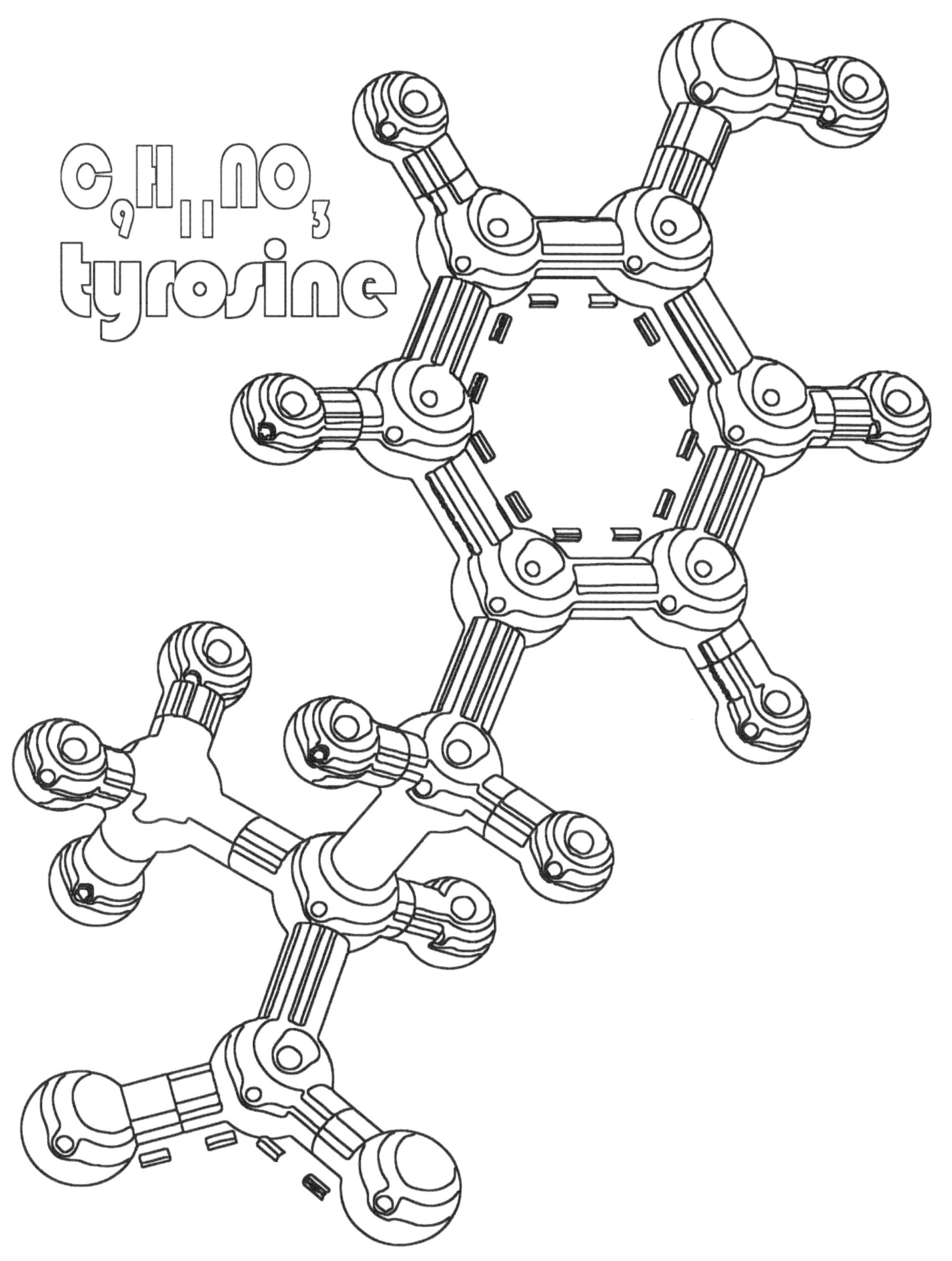

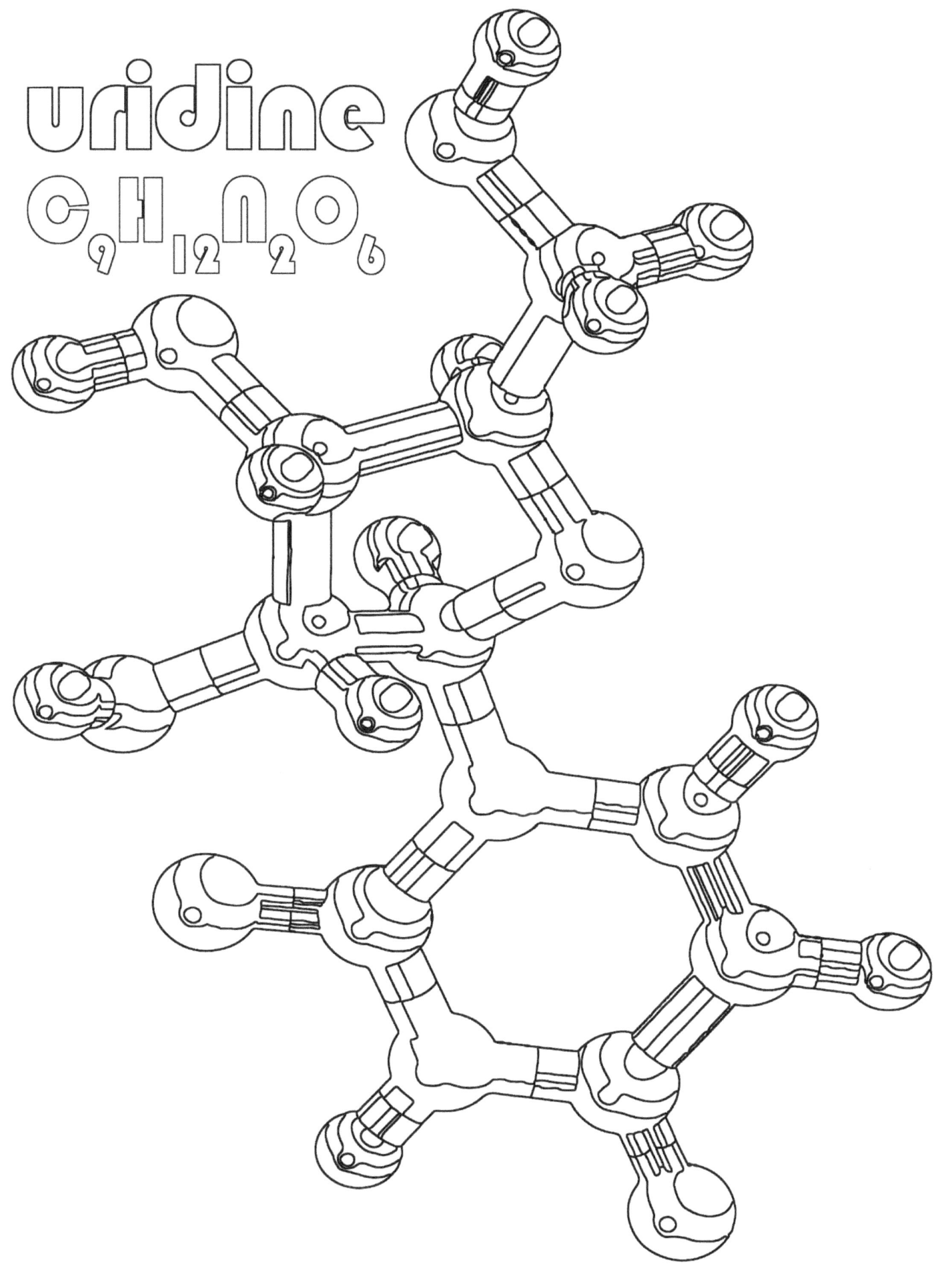

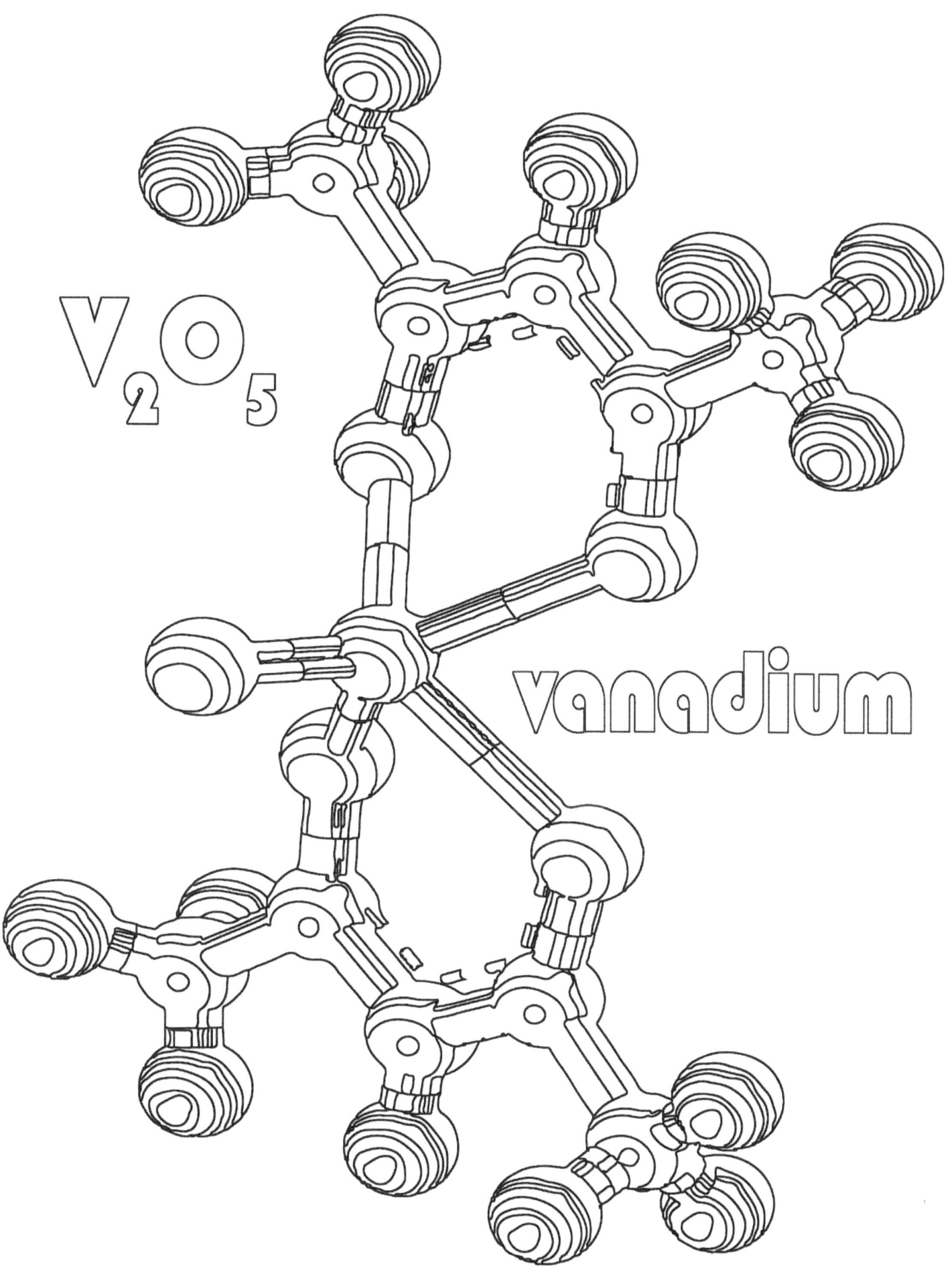

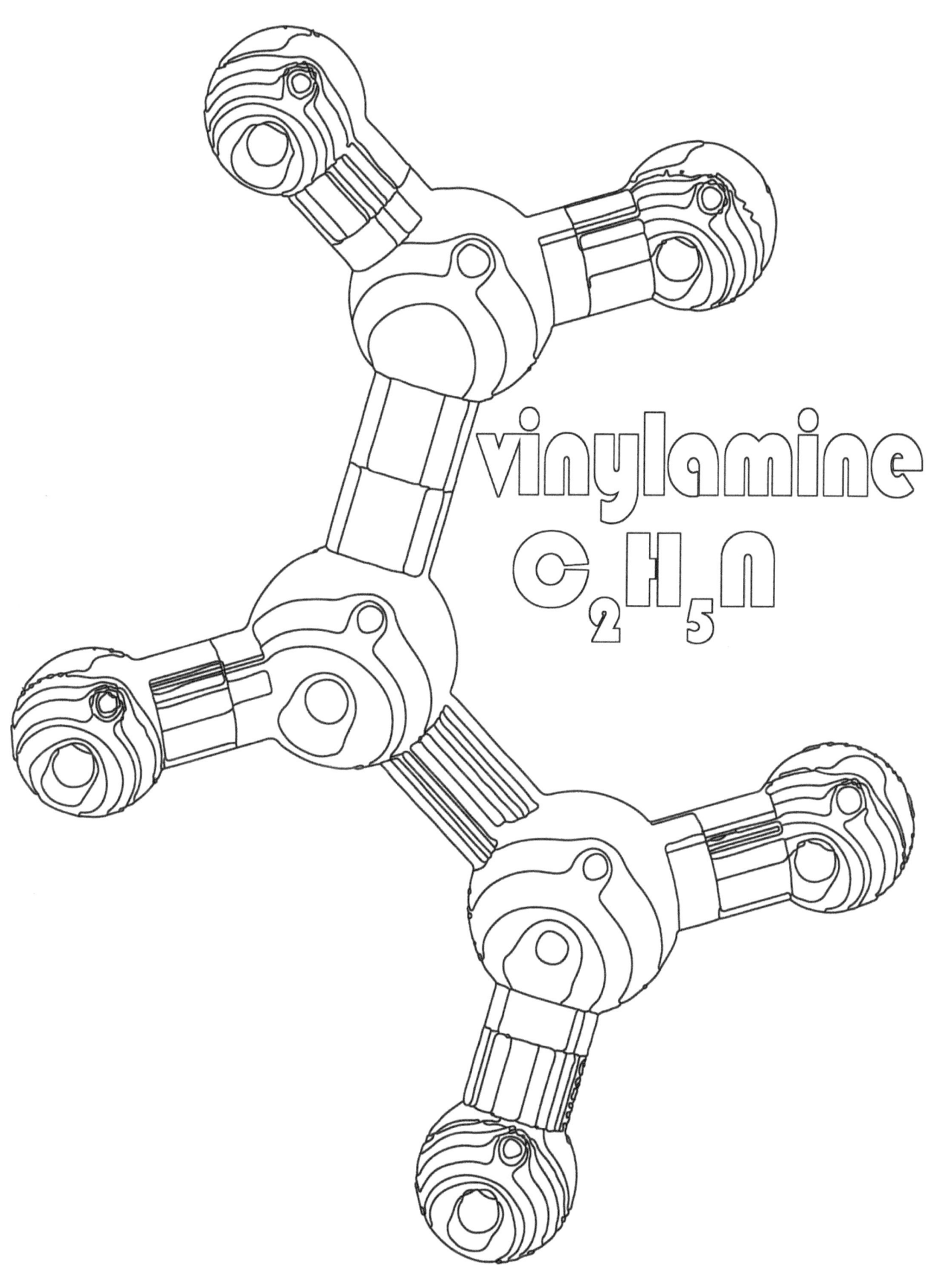

www.ingramcontent.com/pod-product-compliance
Lightning Source LLC
Chambersburg PA
CBHW080657190526
45169CB00006B/2159